FANCY

portraits & stories

DIANE ÖZDAMAR

AMHERST MEDIA, INC. ■ BUFFALO, NY

Dedication

To all the rats whom I miss dearly, to all the abandoned ones awaiting a forever home, and to all the good people who do their best to save the rejected, neglected, and abused ones.

A huge thank you to my friends and family, to Amherst Media, and to all the people who directly or indirectly contributed to the making of this book.

Published by:
Amherst Media, Inc.
PO BOX 538
Buffalo, NY 14213
www.AmherstMedia.com

Publisher: Craig Alesse
Senior Editor/Production Manager: Michelle Perkins
Editors: Barbara A. Lynch-Johnt, Beth Alesse
Acquisitions Editor: Harvey Goldstein
Associate Publisher: Katie Kiss
Editorial Assistance from: Carey A. Miller, Roy Bakos, Jen Sexton-Riley, Rebecca Rudell
Business Manager: Sarah Loder
Marketing Associate: Tonya Flickinger

ISBN-13: 978-1-68203-370-8
Library of Congress Control Number: 2018936012
Printed in the United States of America
10 9 8 7 6 5 4 3 2 1

www.facebook.com/AmherstMediaInc
www.youtube.com/AmherstMedia
www.twitter.com/AmherstMedia

Contents

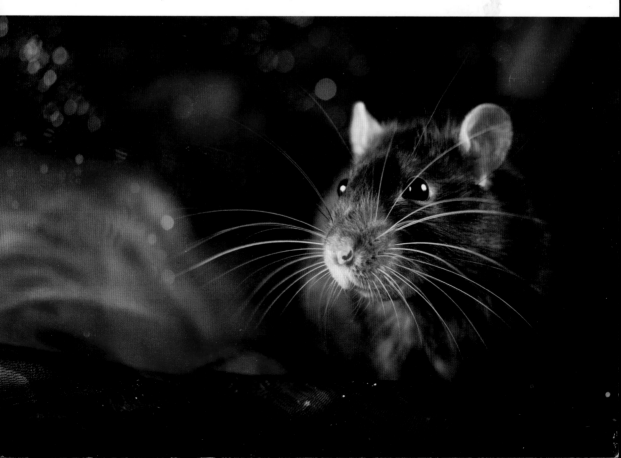

About the Author

Diane Özdamar is a self-taught senior illustrator, photographer, and graphic designer, born in France in April 1985 and currently residing in Montréal, QC, Canada. She has always loved art in all its forms and fell in love with photography when her father presented her with her first camera on her eighteenth birthday.

An animal lover at heart and animal rescue advocate, Diane has been taking rats' pictures since 2006, to find good homes for the abused and abandoned ones she fostered. She soon noticed these pictures not only got people interested in adopting these rats, but also helped other people to overcome their phobia of rats and/or their negative stereotypes.

A large collection of these photographs was exhibited during the 2011, 2012, and 2013 annual show "Animal Expo" in Paris, France, where Diane gave lectures about general rats' care and maintenance, and informed visitors about these lovely creatures.

Introduction

As a child, I could never understand why people despised rats, mice, and other small rodents, as they looked both cute and fascinating to me, be they wild or domestic.

I was about twenty years old when I got my first pet rats, and I would never have imagined this would be the beginning of such an incredible journey. I learned a lot about these wonderful creatures, from their behavior to their needs, and started fostering abandoned and mistreated rats as I was becoming aware of animal abuse.

Finding homes for rats is not an easy task, as most people do not know rodents and other small mammals can be adopted from animal shelters. Unfortunately, as these animals are usually sold quite cheap in pet shops, they often get abandoned after someone decides, on a whim, to purchase them. Thus, I had to learn to take nice pictures of my little protégés, in the hope that I would catch the attention of potential families.

Not only did taking decent pictures help a lot to find good homes for them, but it also led me to help some people overcome their phobia and prejudices, to participate in events focused on teaching people about proper rat care, and most important, to promote adoption instead of shopping.

I have met some incredible people through these years, and incredible rats with huge personalities. This book aims to show you how far from the usual stereotype rats actually are (domestic ones, unfortunately, do suffer a lot from their wild siblings' reputation), and how adorable they can be, from tiny babies to senior rats, no matter what they went through in their lives. I wish these pictures would help people consider giving a second chance to the rejected ones, and maybe adopt animals from their local shelter.

As I know how much said animal shelters and animal welfare organizations struggle to get enough funds, I will donate a portion of the profits of this book to organizations such as L'Arche de Bagheera, Rongeurs en Destress, etc.

Basic Rat Care

Caprice

Adult female rat.
Seal Point Siamese,
Dumbo eared,
standard coated.

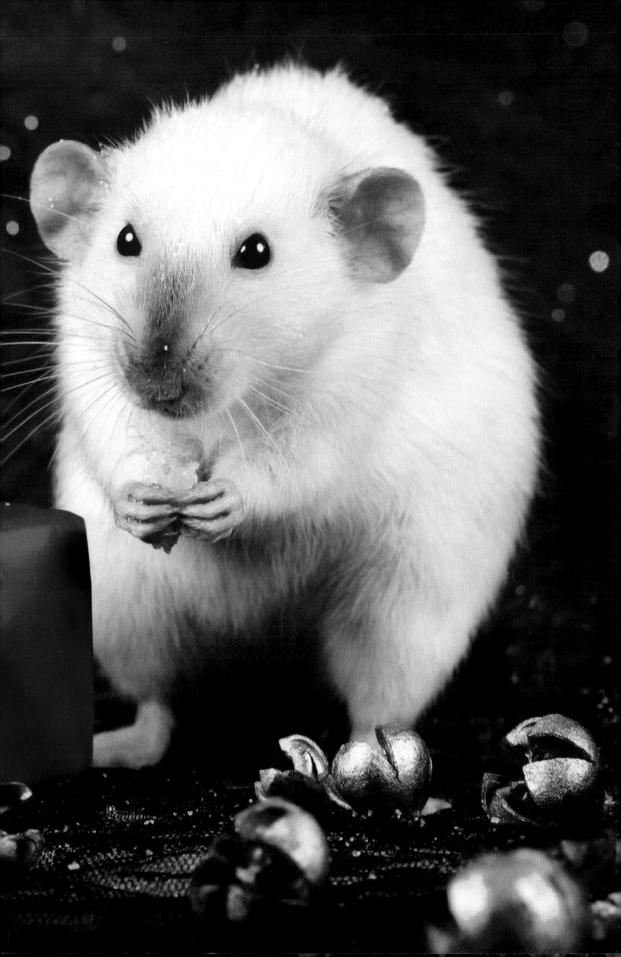

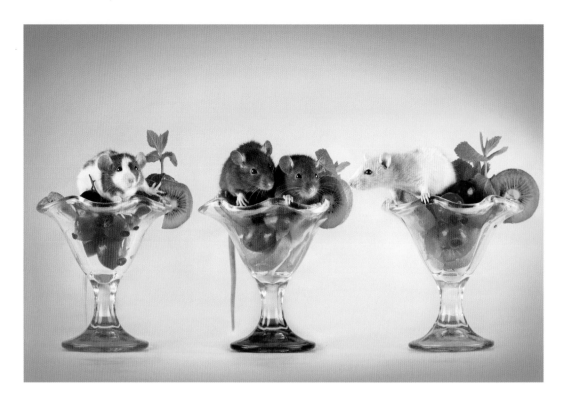

Adopting Rats: How Many, Where, Why?

Rats should never live alone, as they are highly social animals that spend most of their time interacting with each other. Despite how much attention you could give to your beloved rat, this sweet animal can never be fully happy without at least one companion of their own species. Human beings do not have the same behavior, size, and biological needs as rats, so we cannot fulfill a rat's needs in terms of social interactions.

You should always plan to adopt at least a pair of rats of the same sex. Rats reach their sexual maturity around six weeks old and can give birth to up to eighteen babies per litter (usually ten to twelve), which means a single pair could produce about fifteen thousand descendants in just a year.

If you are planning to adopt rats, please contact your local animal shelter or SPCA to give a second chance to the unlucky ones. There may be both young and adult rats up for adoption, as shelters often host abandoned exotic pets (rabbits, mice, guinea pigs, rats, ferrets), as well as cats and dogs. Another option is to contact a responsible breeder who focuses on breeding rats for their health, character, and longevity. Such breeders usually do not plan lots of litters, and females are not bred repeatedly, so you may have to wait. However, adopting from a pet shop or from someone who seems to mass produce rats is absolutely not the best option, as the rats may be in fragile health or have behavioral issues.

Housing

Rats need a lot of space and cannot live in small cages. They should have a lot of room to climb and play (the cage should be at least 80x50x80cm/31.5x 20x31.5in for two to three rats). They should be allowed to roam free for at least one hour per day in a room devoid of electric wires and toxic elements they could accidentally chew. Leaving the cage open in a safe place all the time would be ideal. Be sure, too, to avoid keeping rats in places where they are subject to drafts of cold air; also, keep them out of dusty areas, as these conditions can cause your rats to become sick.

Rats need non-toxic bedding. Pine and cedar wood shavings are strictly forbidden as they contain volatile phenols that are released when in contact with urine, which can cause serious damage to rats'

lungs. Safe bedding options include hemp, flax, paper pellets, veterinary mat, and aspen wood shavings.

At minimum, cages should include two or more drinking bottles (water needs to be changed daily), food bowls, platforms with ladders, hammocks, tunnels (the ones for ferrets are ideal), and small houses so the rats can hide (the "Sputnik" ones are quite popular among rat owners). You can also add small comfortable baskets where the rats can sleep and toys, such as little wooden bridges (no pine wood, though!).

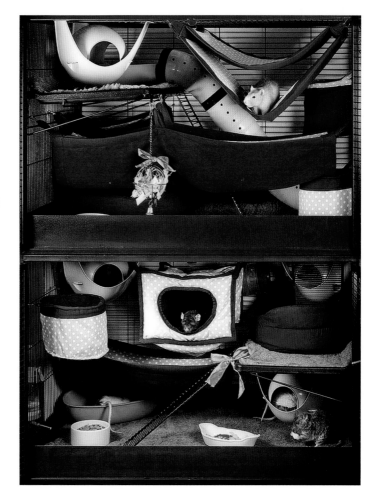

Diet

Rats are an omnivorous species, but certain foods are strictly forbidden. These include alcoholic, caffeinated, and carbonated beverages; raw and dried beans; wild insects; spoiled foods; dried corn; potato eyes and skin; green potato; tomato stem; bitter almonds; seeds of peaches, apples, pears, apricots and cherries; raw peanuts; avocado flesh in contact with the seed and peel; green bananas; licorice; and blue cheese.

Citrus fruits and mango contain d-limonene, which can cause kidney failure in male rats. Sweet potato, eggs, meat, lentils, rice, tofu, artichoke, Brussels sprouts, and cabbage should never be served raw. Avoid fatty foods, foods that contain a high amount of salt and sugar, and sticky foods, such as peanut butter. You can buy appropriate rat food in pet shops and add some fresh fruits and vegetables daily.

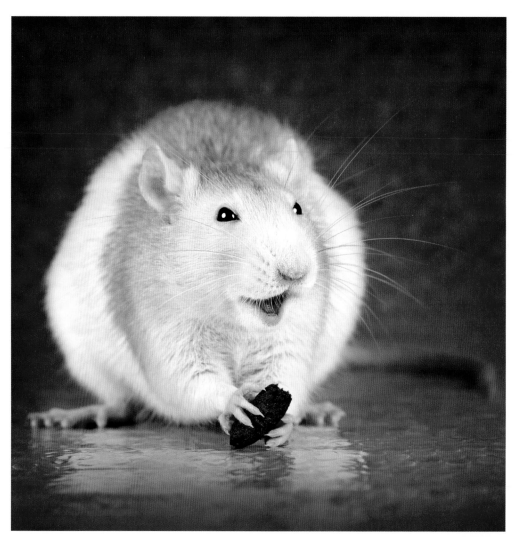

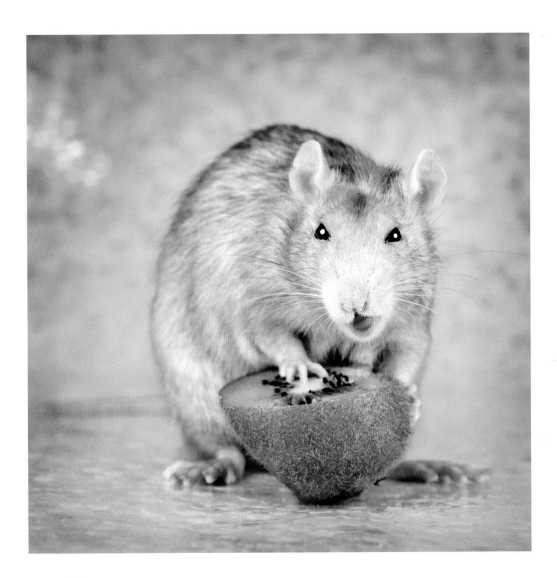

Health

Rats are short-lived (their average life span is two to three years), fragile animals who are prone to respiratory diseases and tumors (female rats are more likely to suffer from mammary tumors than are males).

A rat that displays unusual behavior such as aggressiveness and apathy, has porphyrin secretions around the eyes and nose (a red fluid that looks a little like blood—it is okay for rats to have a tiny bit of porphyrin around the eyes when waking up), dirty and coarse fur, bald patches (except for double-rexes and hairless), makes weird screeching sounds while breathing or breathes heavily, has blood in its urine, a tilted head, or an abnormal mass under the skin should be taken to the vet immediately. These symptoms can be signs of a serious condition and should be properly treated.

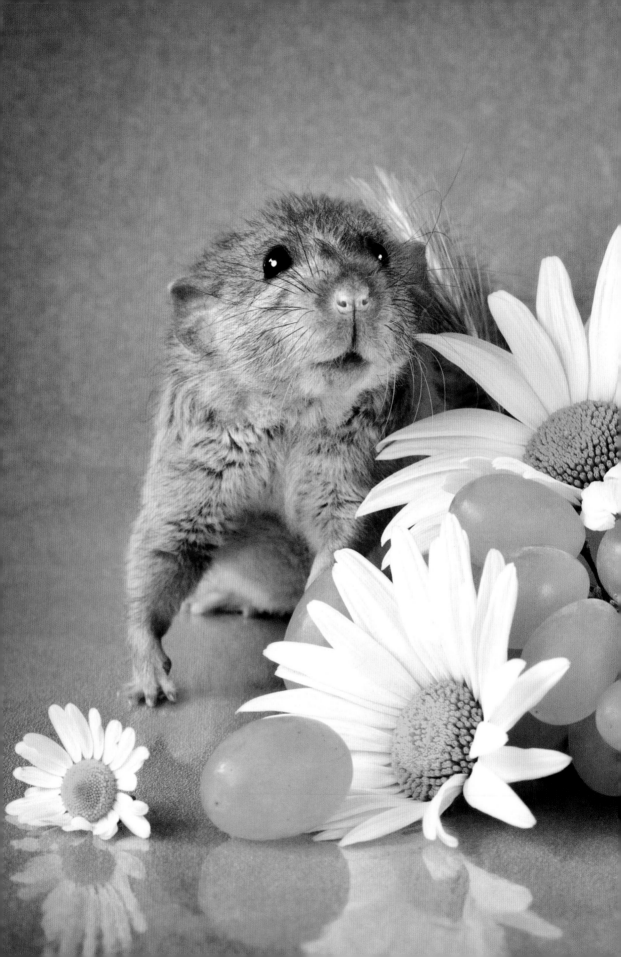

Portraits & Stories

Willy Wonka
Adult male rat. Agouti Self,
Dumbo eared, rex coated.

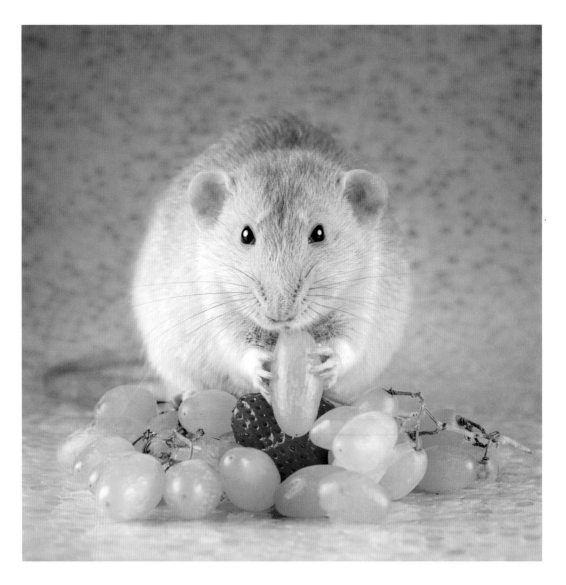

Izumi

Izumi was a very sweet and big rat who was adopted by my friend, Marjorie, when he was about six weeks old. His mother had been mistreated and was about to give birth when she was rescued. The skinny and traumatized hairless doe gave birth to fourteen healthy pups, all of whom grew up to be huge rats.

I had the chance to keep Izumi at my house a couple of times, as I was doing some rat-sitting during Marjorie's vacations. He sure seemed happy to take part in this photo shoot, as he got lots of delicious treats!

Adult male rat from an unplanned rescue litter. Lavender Irish, Dumbo eared, standard coated.

Toutatis

Toutatis was found abandoned with his siblings in a parking lot in Lyon, France. I took him home, along with his brother, Semtex, to foster them until they could get better, as they were weak and scared. When the brothers began gaining weight, they developed a hormone-induced aggressiveness toward each other (this is common among adult males who have undergone trauma and malnutrition), so I had to get them neutered to help them become sociable again. The pair soon became playful and loving.

Toutatis was adopted by my friend, Stouf, and led a happy life.

Adult male rescue rat. Black Irish, standard eared, standard coated.

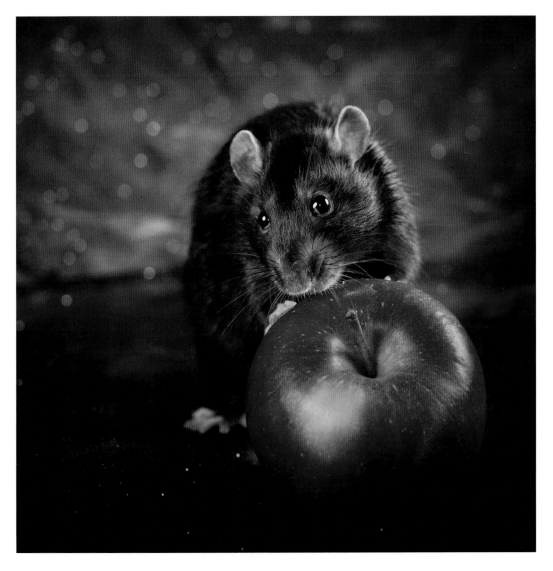

Lysander

Lysander was Izumi's brother. Their rescuer, Udine, asked me to take pictures of the babies to help find them good homes.

I had not planned to fall in love with these two siblings, who kept crawling under my hands and running toward me as soon as I tried to gently take them away to photograph their brothers and sisters. So, I adopted them and named them Lysander and Kaelan.

Lysander was a very affectionate rat who spent hours sleeping on my knees and licking my hands. He loved nothing more than getting belly rubs.

Young adult male rat from an unplanned rescue litter. Agouti Lavender Irish, Dumbo eared, standard coated.

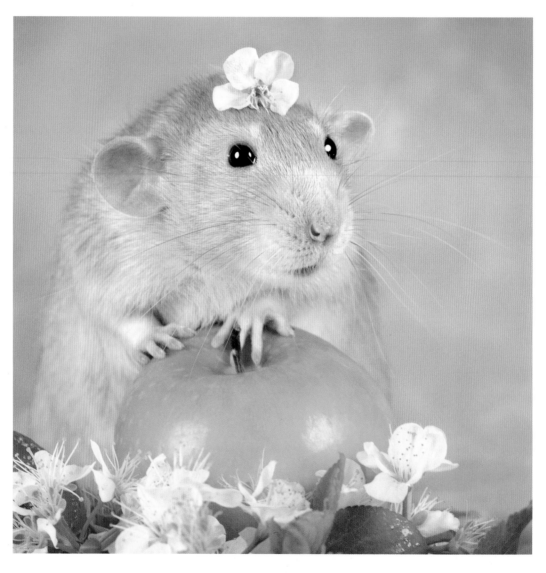

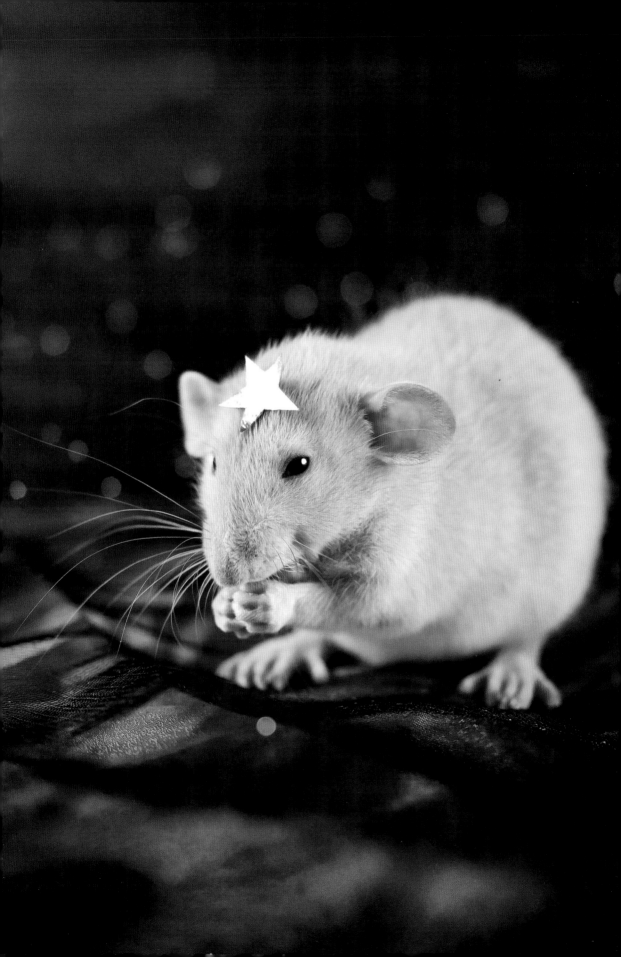

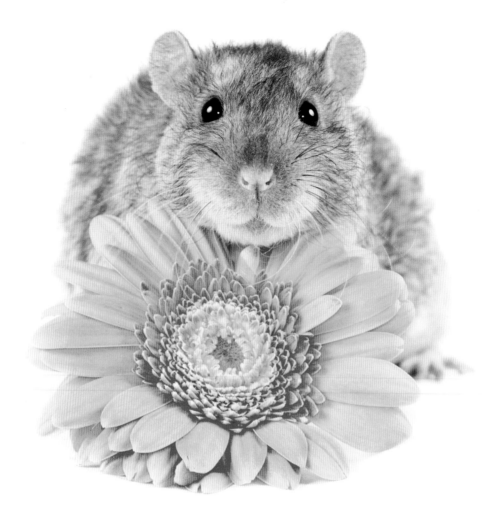

Lillebjörn

Lillebjörn was the son of my beloved rat Feirefiz. His name is Swedish for "Little Bear," as he bore a striking resemblance to a teddy bear.

Lillebjörn was one of the smartest, sweetest rats I have ever met. He took care of the other rats as a mother would care for her babies, from the beginning to the end. He was playful and quite clingy. I used to call him "the Quantum Rat," as he was so eager to get my attention that he seemed to magically appear from everywhere I would lay my eyes.

Adult male rat. Agouti Berkshire, standard eared, rex coated.

Arumi

Arumi was Lillebjörn's nephew. He was adopted by my friend, Marjorie, so I had the chance to rat-sit him a couple of times.

His clown-like behavior oozed through his expressions, and I could not resist taking some pictures of this sweet and curious boy. I remember how funny this photo shoot was: Arumi could not stay still and was so interested in my camera that he attempted to steal it by biting the strap and trying to drag it away. It seemed too heavy for him, and he eventually gave up, but tried again and again during each photo shoot.

Adult male rat. Black Berkshire, standard eared, double-rex coated.

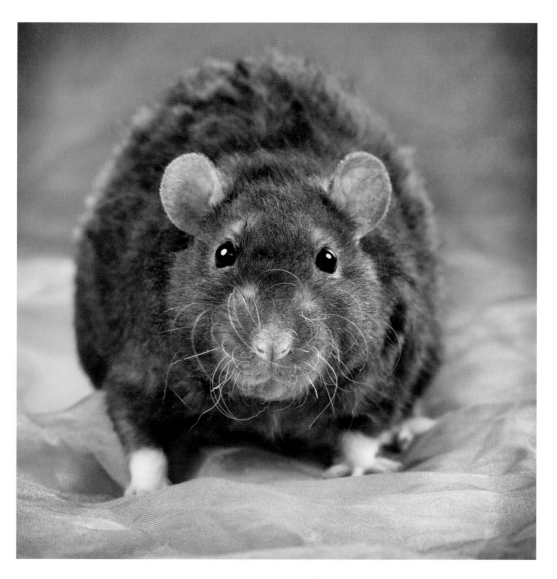

Feirefiz & Pumpkin

My friend, Lyka, brought me her rats for a photo shoot. My sweet Feirefiz and her lovely Pumpkin seemed to be very interested in each other's scents. As there was no risk of pregnancy or to spread diseases (Pumpkin was spayed, and we had been following strict quarantine procedures for the shoot), we decided to introduce the pair to each other. They instantly became friends, and the tiny Pumpkin started grooming Feirefiz. He was so happy that he almost fell asleep, and I had the chance to get a very sweet image, which I hold dear.

Adult rescue rats (male and spayed female). Fawn Hooded, standard eared, standard coated, and Fawn Self, standard eared, supposedly satin coated.

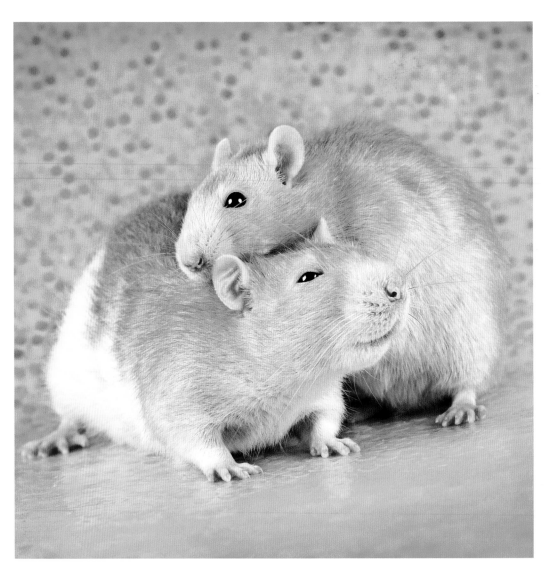

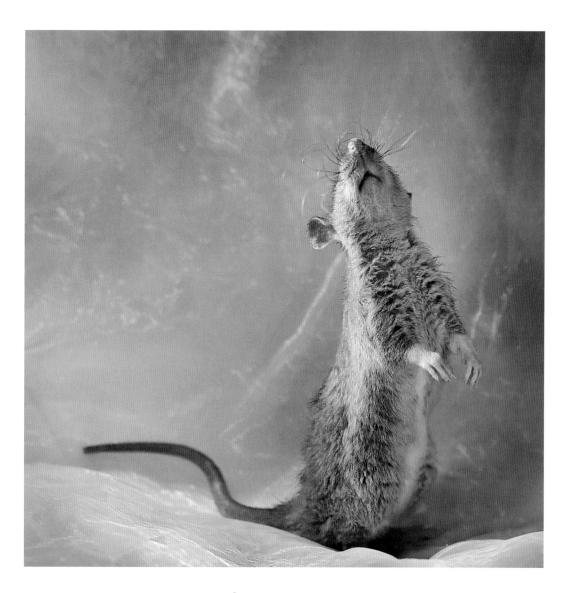

Fenrir

Young male rat from an
unplanned rescue litter.
Agouti Irish,
standard eared,
rex coated.

Fenrir was basically a clown—a bouncy fluff ball with a huge personality, and one of the funniest rats ever. He was very curious and would communicate a lot through his body language. I do not think I have ever seen a rat display such a vast array of postures. He sure was one of the best models I have had the chance to photograph, as he was exceptionally expressive. He was also a sweetheart who loved to climb onto my shoulder to take naps under my hair. Additionally, he was a hide-and-seek champion.

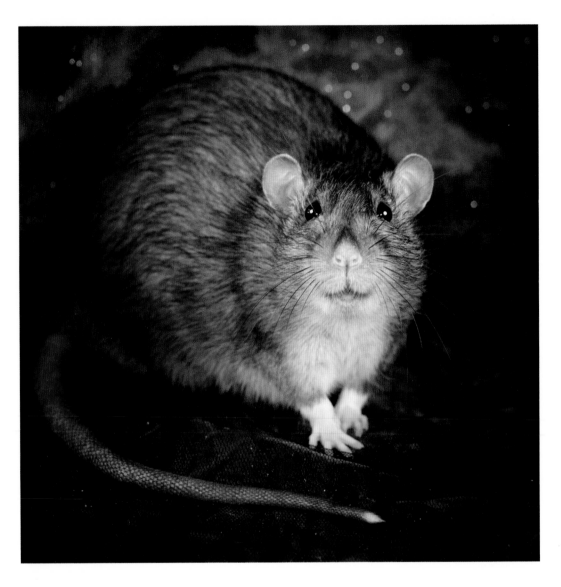

King Julian

King Julian was a fascinating rat who looked just like a wild one (this is how sewer rats actually look; they are absolutely not black with red eyes, as depicted in many movies). He was a gentle giant who adored his owner, my friend, Lorien. She brought him to my house for a photo shoot, and I was thrilled to witness their wonderful bond. King Julian was perfectly relaxed and confident, despite the fact some other half-wild rats prove to be very stressed. He loved licking people's hands and, of course, getting tasty treats.

Adult male rescue rat, half-wild (born from an abandoned domestic doe who had mated with a wild rat). Agouti Irish, standard eared, standard coated.

Gareth & Jack Sparrow

When they were only five weeks old, my sweet Gareth and his brother, Jack Sparrow, were so tiny that they would fit into a Jack-Be-Little pumpkin. Can you believe these cute babies became huge, beautiful boys, weighing twice as much as this little pumpkin? Anyway, I had wanted to make some Halloween-themed shots, and here was the ideal opportunity: two black rats, a small pumpkin, and a dark background. Most people would think these are the perfect ingredients for a creepy picture, but isn't this one adorable?

Baby male rats. Black Irish, standard eared, standard coated.

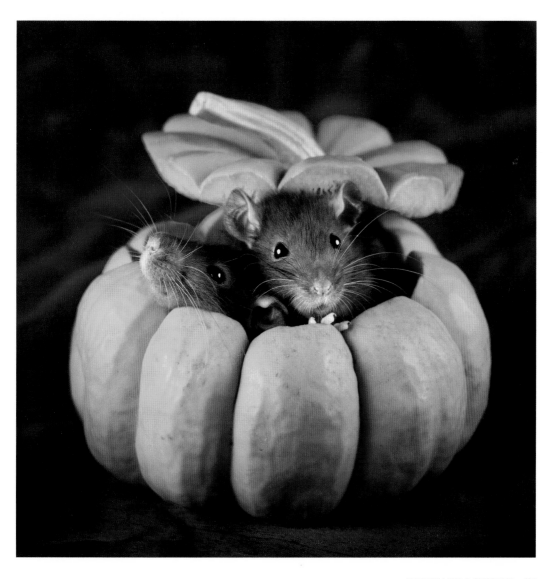

Tjall

Tjall was Lillebjörn's nephew, born at my friend Lorien's rattery, les Karamel'Z. I was looking for a youngster to be a companion to one of my young rats, and I could not resist adopting him. He was one of the sweetest rats ever; he loved everyone and was always willing to take care of the elders. He was very playful and helped many shy newcomers to instantly feel at ease in his presence.

During our shoot, Tjall ended up yellow-faced due to the pollen and juice from all the delicious dandelion flowers he ate.

Young adult male rat. Russian Blue Wheaten Burmese, standard eared, rex coated.

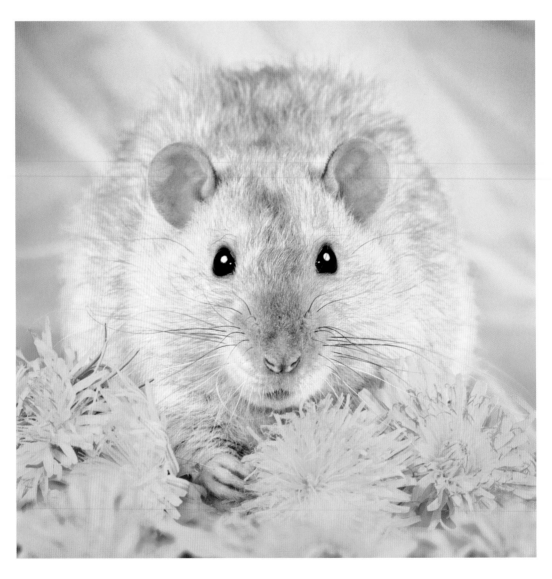

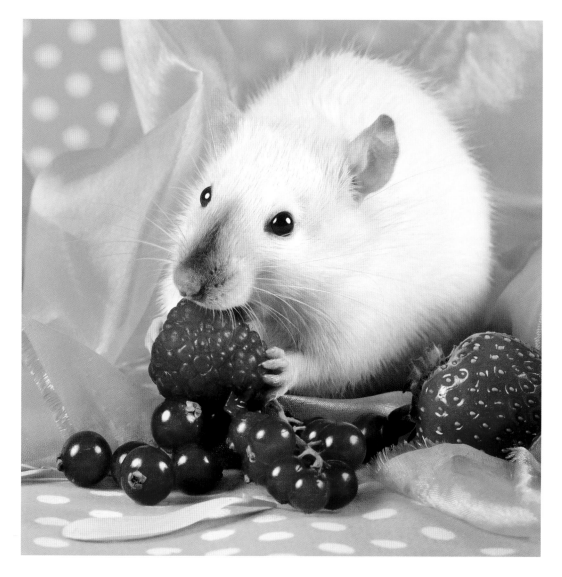

Louis

Young male rat. Seal Point Siamese, standard eared, standard coated.

My photographer friend, Tiphaine, and I were tasked with creating a calendar for the French rat community, SRFA. We had scheduled photo shoots with rat owners, which proved fun and challenging, as we did not know most of the rats and their people.

Louis was one of our tiny models, a laid-back young buck, who was very interested in tasty treats and cuddles. The session was going smoothly until it began to look like a crime scene due to the berry juice Louis had spilled everywhere. We had a good laugh!

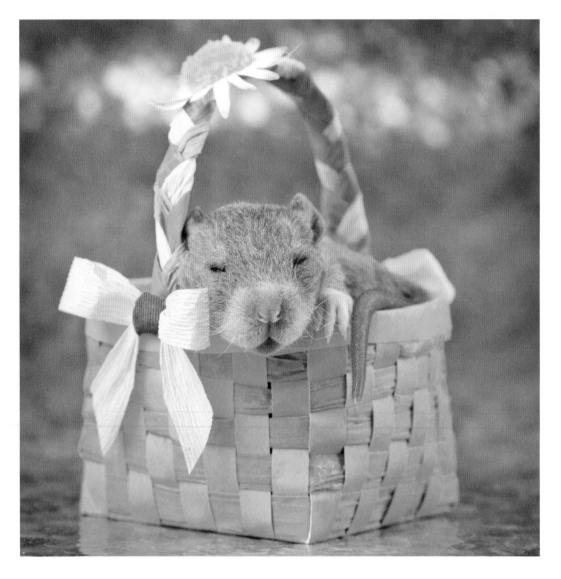

Bobillot

Bobillot was a very sweet little boy born at home, son of my lovely Lillebjörn and the adorable Chlamydiae. He was adopted by Chlamy's owner at the age of six weeks old.

 For this shoot, I made the tiny basket out of colored paper and fabric because I could not find accessories suited to the size of Bobillot and his tiny littermates. While most of Bobillot's siblings were eager to explore their surroundings, he fell asleep, making for the perfect cheesy "cute baby animal in a box" kind of picture. Who said rats could not be as cute as kittens?

Baby male rat. Russian Blue Agouti Irish, standard eared, double-rex coated.

Lysander

Lysander was huge. Looking at this picture, you may think that the apple was small, but that wasn't the case. This rat was the tallest, biggest one I had ever seen. He was a true gentle giant, weighing about one kilogram—yet, he would let even the tiniest rat walk all over him.

He was obsessing over apples, so I had to make the photo shoot happen. Just one minute after the shooting had begun, the apple already looked like a terrible mess, and Lysander looked like the happiest rat on Earth.

Adult male rat from an unplanned rescue litter. Agouti Lavender Irish, Dumbo eared, standard coated.

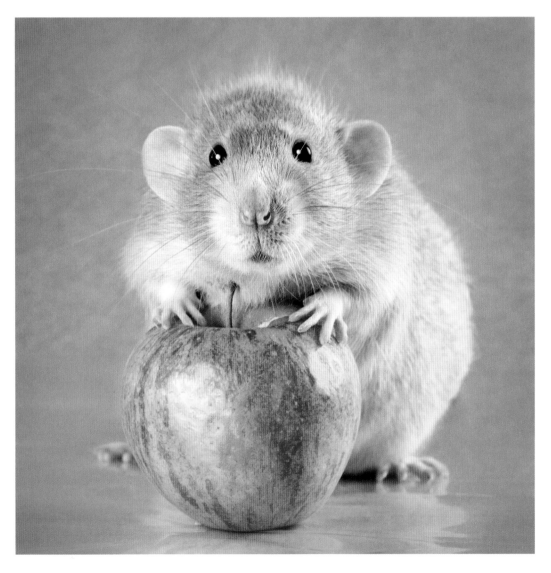

Yela

Yela was found abandoned with twelve other rats in the woods near Paris. Their rescuers managed to capture them before they got killed by cats or other predators. They were very weak and had to get intensive care to heal from their multiple wounds and malnourishment. My friend, Lilou, had taken Yela and Bebop, thought to be brothers, into foster care. She became so attached to them that she could not let them go and adopted them after a few weeks. The pair had the chance to have a beautiful life despite their rough beginning.

Adult male rescue rat. Russian Blue Hooded, Dumbo eared, standard coated.

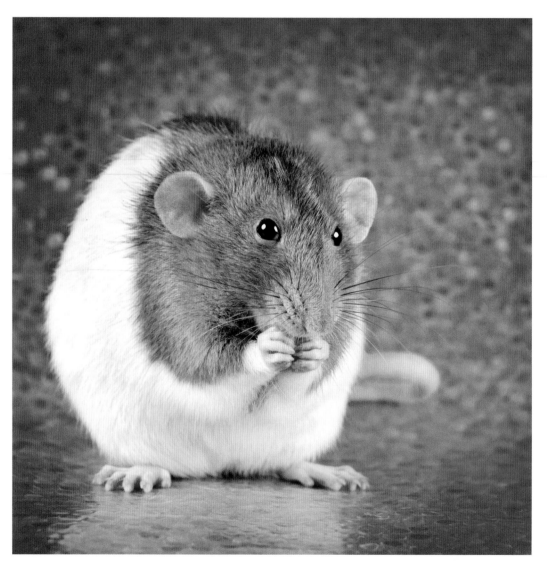

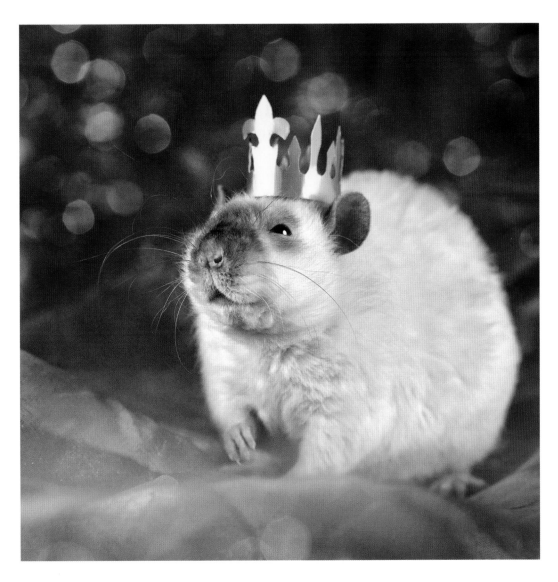

Lorich

Senior male rat from an unplanned rescue litter. Seal Point Siamese Hooded, standard eared, rex coated.

Lorich was the sweetest rat ever, always happy and begging for cuddles, and grooming my hands as soon as he got the chance to. He was the gentle chief of the pack, so I thought it would be funny to make him a little crown and take some pictures. He could remove the crown by shaking his head slightly, but he was so happy to get cheek scratches that he stood still for about a minute, which is a miracle, as rats can be very active! This shot perfectly sums up his mellow behavior, and his social status as the king of the colony.

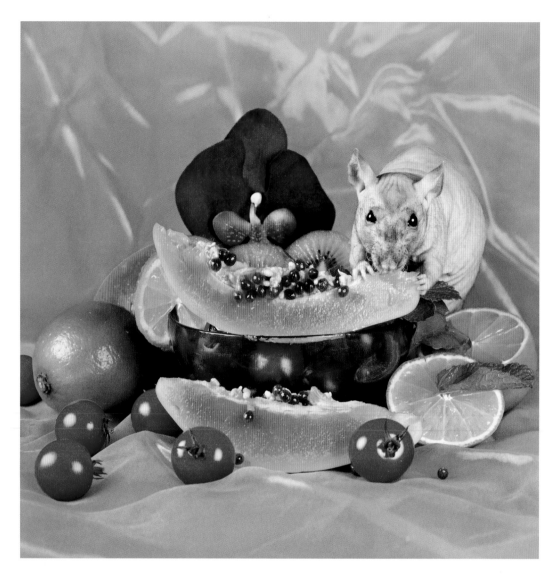

Black Betty

This is another photo from the shoots my friend, Tiphaine, and I did for a rat-themed calendar. I had to create a very summery picture for the month of June, featuring this gorgeous hairless girl. She was so obsessed with all the fresh fruits available that she was not even interested in my camera, thus the shoot was incredibly smooth. I had a lot of fun with this photo session, and Black Betty seemed to enjoy it as much as I did. She was a very sweet and funny rat.

Adult female rat. Black Self, standard eared, hairless.

Gareth & Melehan

Young male rat and baby male rescue rat. Black Irish, standard eared, standard coated, and Black Hooded, standard eared, standard coated.

How not to enjoy delicious fresh fruits during the warmest days of summer? Needless to say, these two cute fluff balls absolutely loved this photo shoot! Melehan, the younger rat, was very fond of this large watermelon slice, while Gareth seemed more interested in the peaches that were out of reach on a nearby table. He waited until I was busy photographing Melehan to jump on the table, steal a peach, and desperately try to run away with the huge fruit, which resulted in a juicy mess throughout my living room!

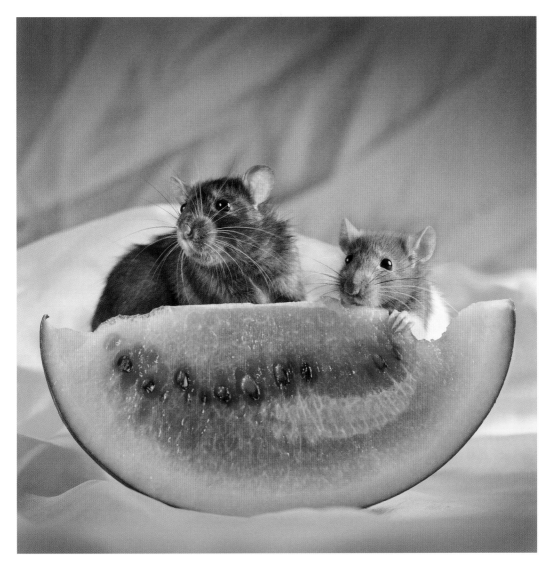

Grímnir

Grímnir was the son of my beloved Lillebjörn and the sweet Chlamydiae. From the first days of his life to the very end, he remained one of the "lickiest" rats ever, and was extremely playful and affectionate. Can you resist those adorable little paws, mini teeth, and tiny pink nose? I sure could not, so I adopted Grímnir and his brother, Svölnir. The pair had inherited their father's "Quantum Rat" character, and they never stopped trying to grab my attention and followed me everywhere. I loved these cuties very much!

Baby male rat. Agouti Hooded, standard eared, rex coated.

Owain

Owain was one of my first rats, a very big, friendly boy who'd had a rough time getting along with his friends during his teenage phase, but later became an absolute sweetheart. I often called him Mr. Clean, as he would never let go of anyone's hand before he had it entirely groomed. He was so fluffy and squishy that the whole pack used him as a pillow during their daily naps, and he seemed happy about that. He was very old when I took this picture; paralysis had begun to affect his hind legs, hence his crooked toes.

Roll the Dice

Roll the Dice was the sister of my lovely Brumear and the cousin of my sweet Feirefiz. She was born at my friend Limë's rattery, La Tarte au Citron, and I had the chance to rat-sit her for some days. She was a funny little girl, insanely playful and smart. I do not think I have ever seen a rat with so much energy. I was very lucky during this photo shoot, though, as I managed to get her to stand still for a couple of seconds and to take a decent picture, which was some kind of mini-miracle.

Young female rat. Black Dalmatian, standard eared, standard coated.

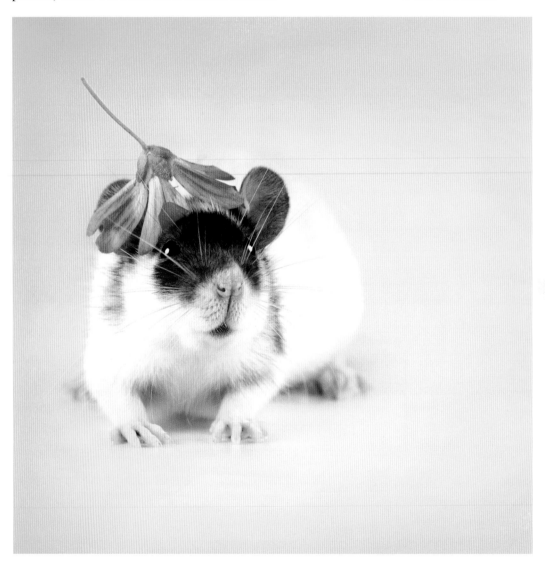

Toutatis & Semtex

Adult male rescue rats.
Black Irish,
standard eared,
standard coated.

These gorgeous boys were found abandoned in a parking lot in Lyon, France. I took them into foster care until I could find them good homes. This is one of the first shoots I did of the brothers, and I absolutely love how this picture came out, as their personalities were oozing through their poses, despite the fact they were still afraid of people. Toutatis was the more laid-back of the pair, while Semtex was quite curious and playful. They both had the chance to be adopted by wonderful people (Stouf and Kyrielle) and to live with many other rats.

Blurp

Blurp was an unusual rat: he was small and very playful, even at an old age, while most males become rather big and lazy. He looked much younger than he actually was when I took this picture, and even lived to the age of three and a half, which is very old for a rat. After his companion died, his former owner gave him to a friend of mine, who tried to introduce him to her rats. Unfortunately, Blurp never got along with them, as he had become a bit grumpy as he aged. He was the brother of my sweet Lothar.

Senior male rat. Russian Blue Split Capped, standard eared, velveteen coated.

Lothar

Senior male rat. Black Mismarked Capped Headspotted, standard eared, velveteen coated.

Lothar was Blurp's brother. His story is the same, but the two rats had different owners: his companion had died, and the owner gave him to me so he would not live alone. He immediately befriended my other rats and seemed to regain youth as he started playing with the youngsters.

This photo was one of the first from my "fruits and vegetables with faces" series. I had a lot of fun with this one, as sweet Lothar was as far from a mighty monster as possible. He was actually one of the sweetest and most friendly rats ever.

Fenrir

Remember the little clown showing off his belly *(page 21)*? This is the same cute boy, two years later. This rat never seemed to age and remained incredibly playful, even when he got old. His favorite game was to crawl into a box filled with paper, tissue, and fabric to look for treats. This shot is the result of a whole "hunt for treats" session, coupled with my ninja reflexes that involved grabbing the mini hat (homemade, like all the other accessories), quickly putting it on Fenrir's head, and framing and shooting before Fenrir would dive into the box again.

Senior male rat from a rescue litter. Agouti Irish, standard eared, rex coated.

Little Lords & Tiny Ladies

These sweet babies were my Lysander and Kaelan's siblings. This was one of the shots from the photo session I did to help their rescuer find good homes for those adorable fuzz balls. While some of the rats were still eager to explore, yet a bit tired when I took this picture, most of babies had already fallen asleep on these comfortable heavy pieces of red and gray velvet. This is one of my favorite pictures from this photo session. Those little shiny eyes are absolutely irresistible.

Baby rats from a rescue litter. Mink, Lavender, Cinnamon, and Lavender Agouti, all Dumbo eared and standard coated.

Citrate de Betaïne

Citrate de Betaïne belonged to my friend, Babbou. He was a very sweet rat with the most beautiful and softest curls I have ever seen. He even had a hair part on his head and looked like a very posh dandy. His attitude was true to his looks: he was quite the refined gentleman when grabbing the food I gave him, eating slowly and making sure there would not be any leftover food scattered in my mini-studio. This stunning boy sure had a very unique character!

Adult male rat.
Russian Blue Variegated
Wedge-Blazed,
Dumbo eared,
rex coated.

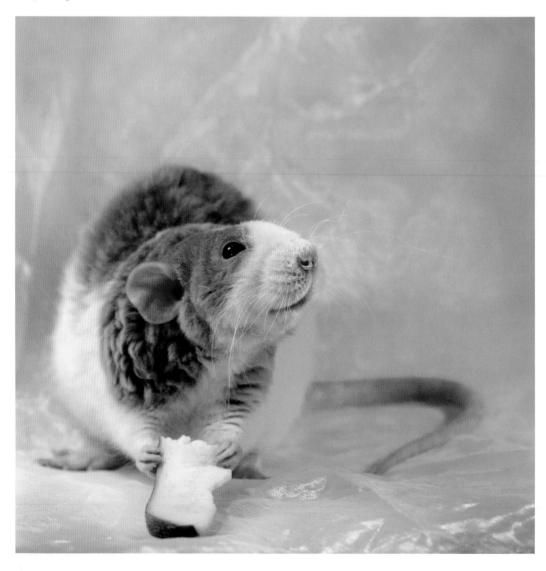

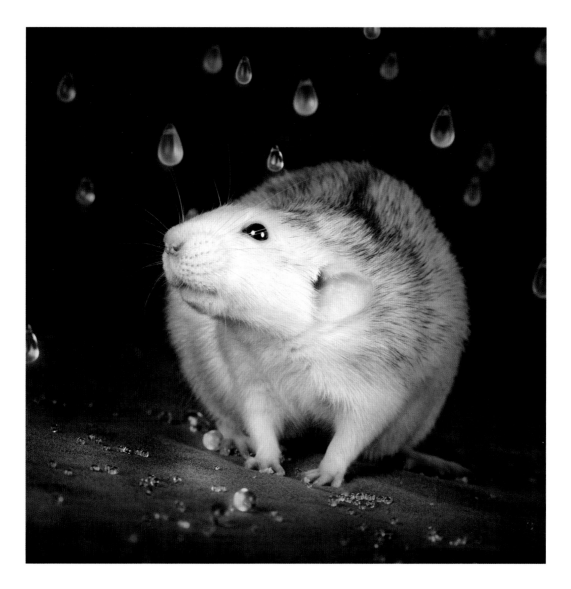

Snow

Adult female rat. Black Roan, Dumbo eared, standard coated.

This is another photo that was taken when making the rat-themed calendar. Snow was not our official model for the month of February, but she seemed so intrigued by the mini-studio that we finally let her jump on it and have some fun with the drop-shaped glass beads. She was a stunner: we got much better photos of Snow than we did of Wifi, the sweet girl we were initially photographing. This lovely, chubby girl was a natural-born model and was rewarded with some tasty pieces of fresh fruit.

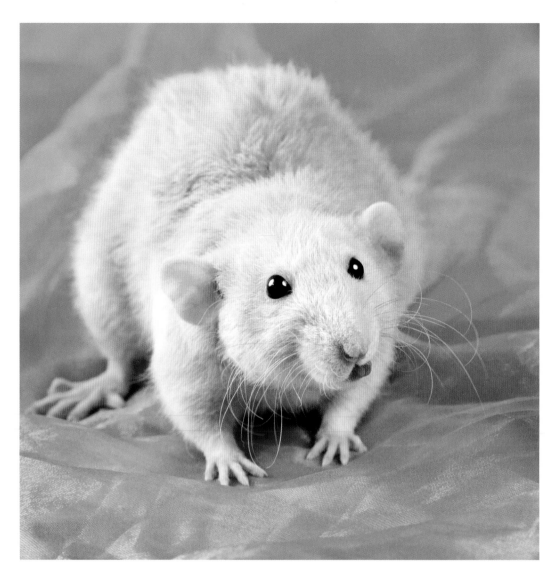

Chlamydiae

Chlamydiae was the cutest rat ever and an incredibly sweet girl who adored people. Her owner, Manzelle, had to go abroad for a while. She brought Chlamy and her sister, Niobé, to my home so I could take care of Chlamy's litter while she was away. I soon found out that Chlamy was very trusting, and I was incredibly moved when she started to drop her newborn babies into my hands before wandering into my apartment, so I could keep them warm. She and Niobé both were adorable, very smart girls who loved playing and napping on my shoulders.

Adult female rat. Russian Fawn Irish, Dumbo eared, rex coated.

Charlotte

As my friend, Tiphaine, and I had to prepare a large photo exhibition to decorate the Exotic Pets pavilion and to illustrate all the educational materials (leaflets, posters, flyers) for the annual pet fair, Animal Expo, in Paris (we were volunteers, informing people about rats' care and maintenance and promoting adoption instead of shopping), we had to photograph lots of small mammals. Sandrine, who had lots of adorable rats, allowed us to photograph the lovely Charlotte. I fell in love with that sweet little rat. She was very gentle and curious.

Senior female rat. Black-Eyed White, Dumbo eared, standard coated.

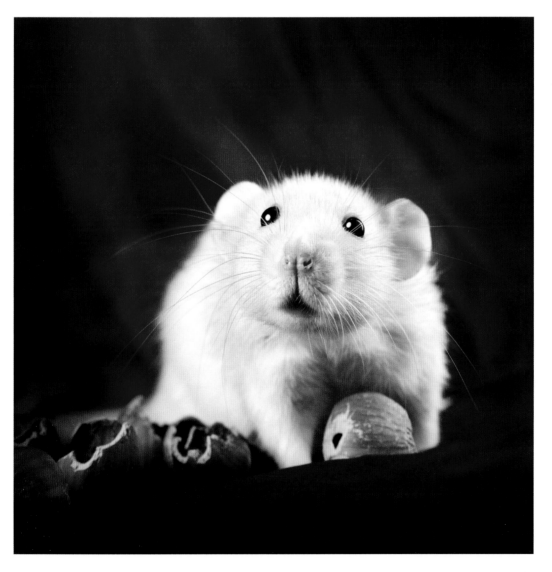

Gareth

Gareth was a very delicate rat, with graceful movements and a dandy-ish attitude—quite a unique trait among all the rats I have known. His small white mittens made him look even more elegant.

This cute photo of Gareth as a baby perfectly captured his essence. This sweet boy never was the first one to come to say hello when I walked by, but that was just because he was too well-behaved to run over all his friends. I used to call him "the Dandy Rat."

Baby male rat. Black Irish, standard eared, standard coated.

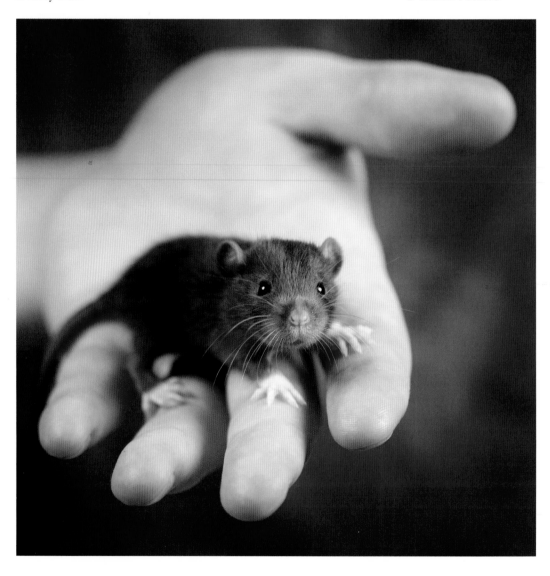

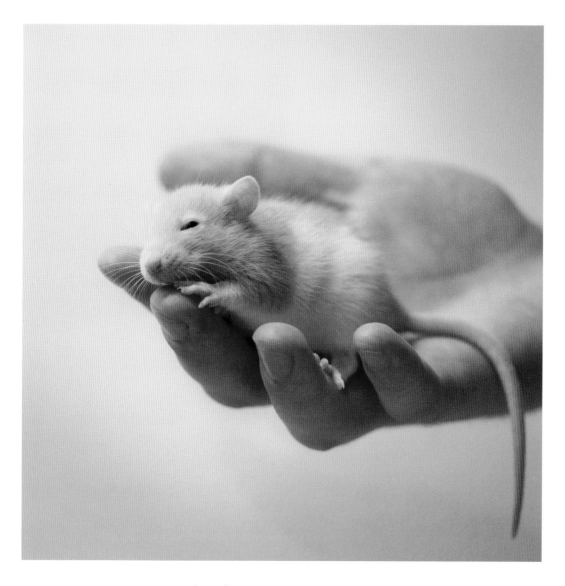

Feirefiz

Baby male rescue rat.
Fawn Hooded,
standard eared,
standard coated.

Have you ever seen such a confident baby? Before becoming the huge boy (almost 700g!) shown in the photo with sweet Pumpkin *(page 20)*, he was a very tiny rat who would fit into the palm of a hand. He was so trusting that he would fall asleep as long as there was someone to gently talk to him.

This rat was really special and dear to me; he was one of the smartest I have ever met, and would take care of the newcomers as if they were his own babies. He was also fond of bringing food to and grooming the elder rats, which really amazed me.

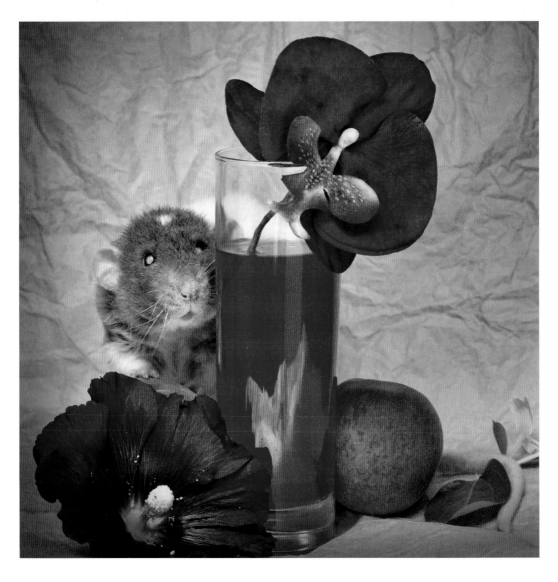

Thor

When I met Thor, I did not think he would survive for more than a few days. The poor rat was rescued from a breeder who had decided to retire and was getting rid of his sixty rats. Most of them were old and in pretty bad shape. Thor was no exception: he was blind, suffered from pneumonia, and was terrified of people. I took him home, along with five other sick rats. He managed to recover and learn to trust people again, and became a very playful rat, despite his old age. I kept Thor and Bélial and found good homes for the four remaining rats I fostered.

Senior male rescue rat. Russian Blue Bareback Headspotted, Dumbo eared, rex coated.

Melehan

Melehan was a "Sure, I can take pictures of the rescue babies to help you find them good homes" fail. I was not supposed to adopt any rat at that time, but this cute baby put so much energy into making me fall for him that I had no choice but to keep him. Who could resist such an adorable face? Melehan was even cuter in person and also very clever. He learned many tricks by himself and amazed me each day with his problem-solving personality. He was also incredibly sweet and loved everyone, rats and people.

Baby male rat from a rescue litter. Black Hooded, standard eared, standard coated.

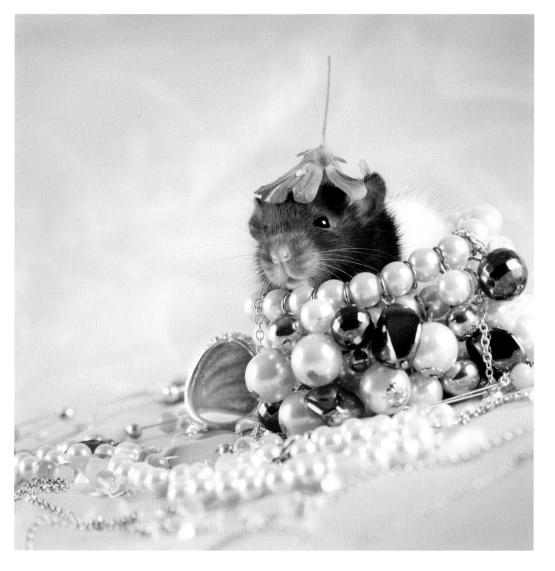

Aegir

My friend, Stouf, adopted two rats who were not supposed to be pregnant—but alas, they soon gave birth to many Blue babies. It was most likely that these little pups were highly inbred, and finding them good homes was an urgent matter, as Stouf could not keep them all. Following my heart, I adopted the very tiny Ægir, who soon became huge and had a grumpy face, enormous cheeks, and very funny expressions. He almost had human attitudes and was a very lovely rat with an obsession for cooked pumpkin.

Adult male rat from an unplanned litter. American Blue Self, Dumbo eared, standard coated.

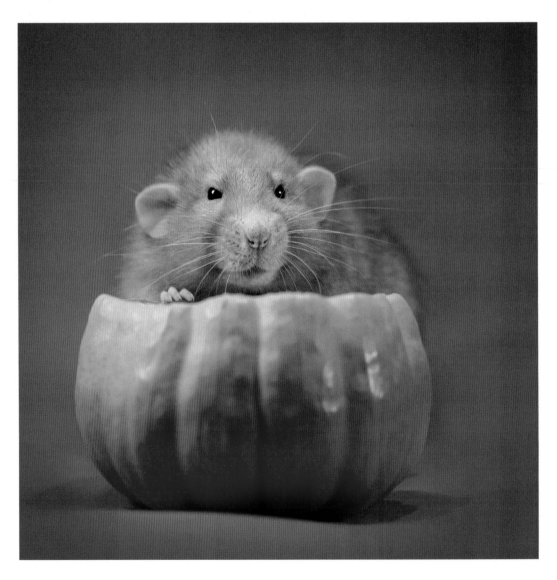

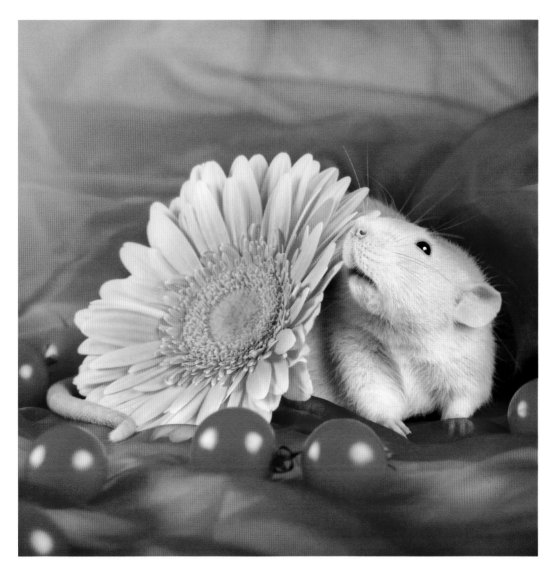

Peach

*Adult female rat.
Fawn Hooded,
Dumbo eared,
standard coated.*

This is another shot from the calendar series; this image was chosen to illustrate the month of August. The lovely Peach was not very willing to pose (exploring sounded so much better to her!) until I placed this Gerbera daisy into the mini-studio. She was quite intrigued by the flower and stopped wandering away. I was then able to pet her, which she seemed to enjoy very much, as she laid on the soft fabric and let me arrange the flower and cherry tomatoes. She would not move as long as she got enough cuddles. She was such a sweet rat!

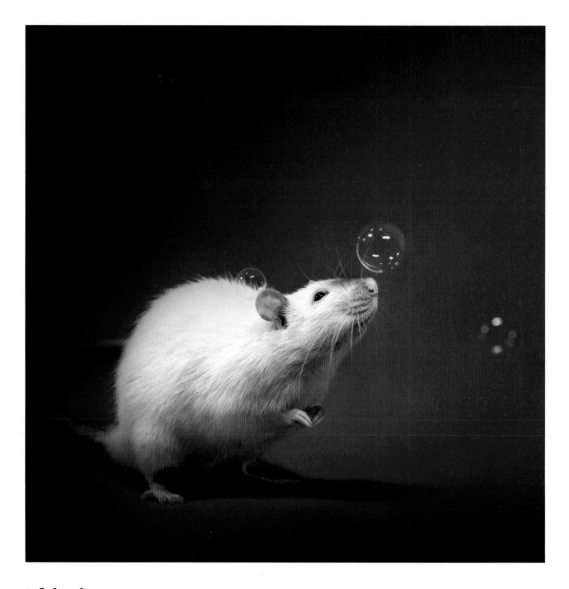

Thjazi

This is one of my luckiest shots ever. I started blowing soap bubbles during a photo session with Thjazi, who acted a bit cautious at first. This bubble popped a second after I took this shot, and I never managed to get another one after this, as Thjazi discovered popping bubbles was the best game ever. He began chasing them, jumping around, and trying to catch them with his little hands. It was so adorable, I blew some more bubbles just for him from time to time. My other rats did not like it so much, though Thjazi's brother, Thorim, seemed to enjoy it, too.

Adult male rat from a rescue litter. Seal Point Siamese Hooded, standard eared, standard coated.

Pietro Pagello, Feirefiz & Inoa

I had gone to visit my friend, Tiphaine, to photograph the rescue litter she was fostering and to meet my sweet Feirefiz for the second time, when these three little rascals stole a cookie from us. They were so cute, we could not bring ourselves to take it back from them (however, we tried to avoid them eating chocolate), and we took some pictures instead. This was the very first time I saw rats eating something without trying to steal it from each other, and this made for a very cute group portrait, which I hold dear.

Baby rescue rats.
Fawn Roan,
Fawn Hooded, and
Fawn Self,
all standard eared,
standard coated.

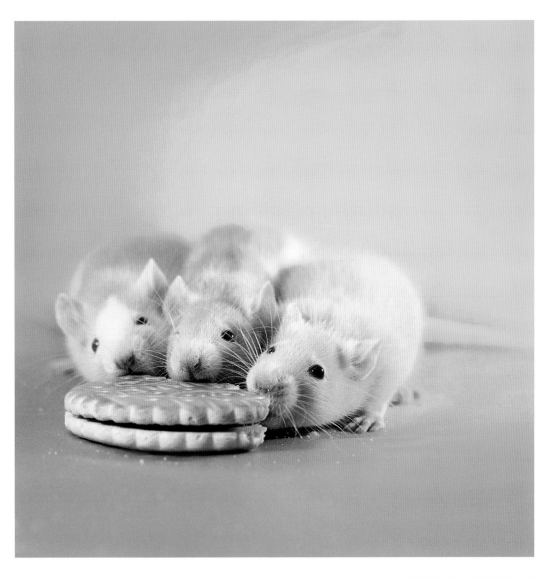

Heimdall

Heimdall was a tiny rat with a huge personality. He was born at La Tarte au Citron, a French rattery, and was a cousin of my lovely Feirefiz. They both shared an intense love of humans, following me everywhere, and walking all over the other rats to be the first to get cuddles.

Heimdall soon found out that squeaking for no reason would help him get the attention of people, and he became a very vocal boy. He even faked being annoyed by other rats so I would come to "rescue" him. I nicknamed him the Drama Queen.

Adult male rat. Mink Varihooded (Variegated Hooded), Dumbo eared, standard coated.

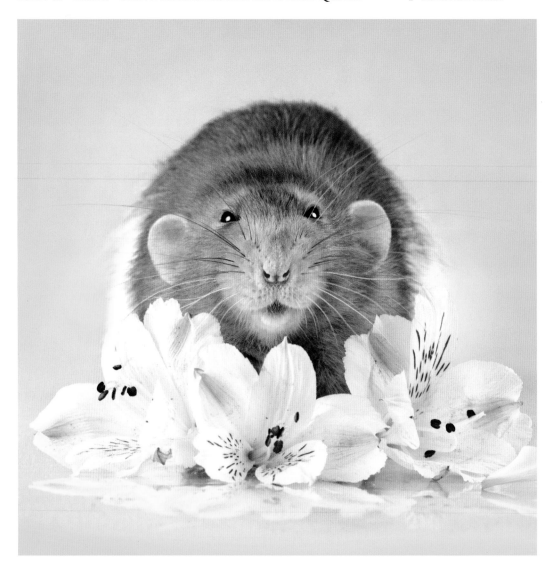

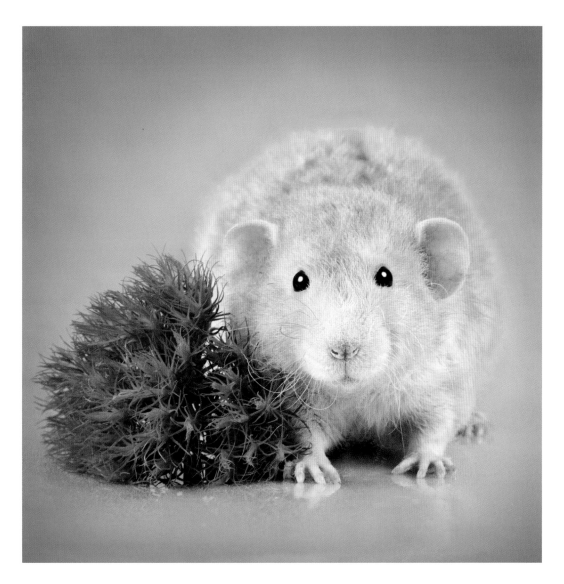

Dellingr

Young male rat. Fawn Self, Dumbo eared, rex coated.

Dellingr was quite similar to his uncle, Herjan: a sweet fluffy ball of pure love and joy who loved nothing more than getting belly rubs and head scratches. He would follow me anywhere and climb along my legs to reach my arms and get cuddles, which was a bit painful, as he was quite heavy and had sharp little claws. He was so cute that he was easily forgiven, though! He was a little more possessive than Herjan and used to push away the other rats and crawl under my hands to get all the strokes. I loved him very much!

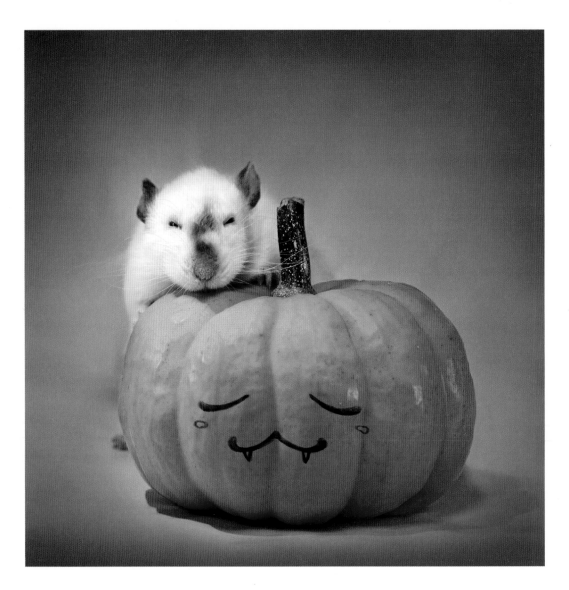

Thorim

I had adopted Lorich and was fostering his brothers, Thorim and Thjazi, for some days until their owner could retrieve them; however, she suddenly decided not to do so, and to my great joy, I had the chance to keep them, as well. The three brothers grew together and had an incredibly strong bond. Lorich was very licky and cuddly, Thjazi was quite playful, and Thorim was the narcoleptic one! He had a very mellow character and used to fall asleep at the sound of my voice, especially when I was softly singing. This picture perfectly sums him up.

Young male rat from a rescue litter.
Seal Point Siamese Hooded,
standard eared,
velveteen coated.

Thor

Remember the first picture of Thor *(page 46)*? He was still a bit shy then, trying to hide behind the small glass of fruit juice and peaches. However, some weeks later, he had gained full trust in me and did not need to hide anymore. I could pet him and he would start grooming my hands and bruxing and boggling (which is, for rats, similar to cats purring from intense joy).

I was amazed to see how far he had come, knowing how sick and traumatized he was when I first met him. Despite being blind, he had no trouble at all living a normal life!

Senior male rescue rat.
Russian Blue Bareback
Headspotted,
Dumbo eared,
rex coated.

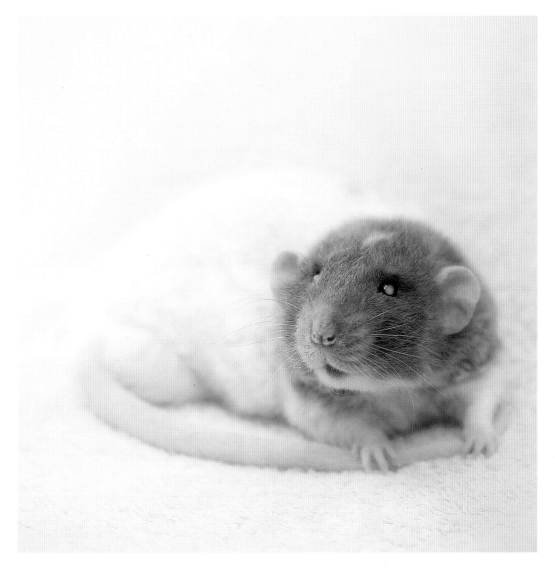

Dioné

This beautiful girl was my lovely Dellingr's sister. I had the chance to rat-sit her, along with Dotty and Kihara. She was very sweet, as mellow-tempered as her brother, and quite playful! She exactly knew how to beg for cuddles and little bits of tasty foods: she had that adorable Puss in Boots stare and would use it, while lowering her huge ears, to look as desperate as she could. She sure knew how to get what she wanted, and quickly understood that getting photographed also meant receiving delicious treats.

Adult female rat. Agouti Berkshire, Dumbo eared, rex coated.

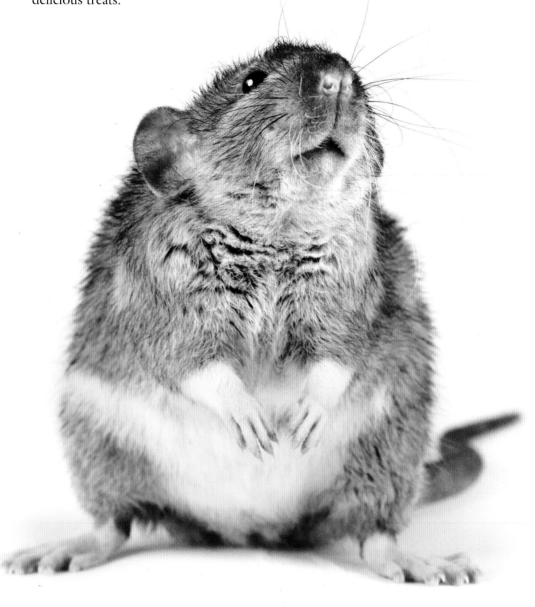

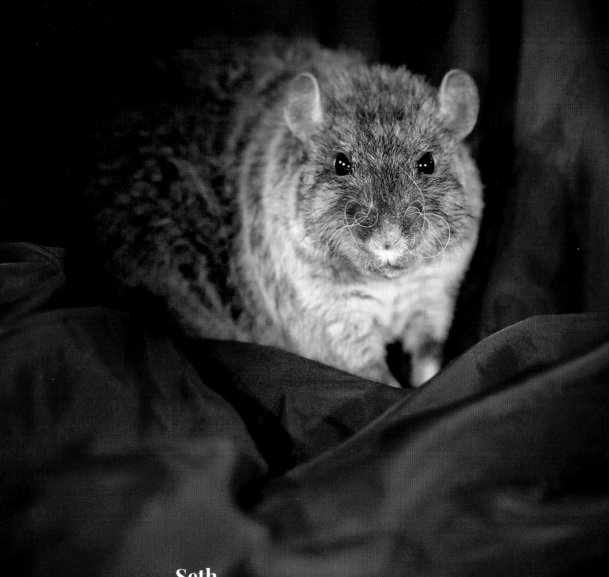

Seth

Seth was a big, beautiful boy whom I took into foster care with his supposed brother, Belphegor. They were "leftovers" from a retired breeder who had stopped taking care of his animals, so they were in a pretty bad shape when I got them home.

Seth was mellow and would fall asleep anywhere, as long as he could get some head scratches. He was quite cuddly and quickly gave me his full trust. He was adopted by Emeline, along with another rat, Odin, whom I kept in foster care. They both lived very happily.

Hephaïstos le Rat

My friend, Chnou, brought me her rats (Hephaïstos, Face Qui Rit, and Willy Wonka) for a photo shoot, and while they had never experienced this before, I was very surprised at how smoothly the session went. They were very relaxed and playful, and Hepha had some really great facial expressions.

This picture melted my heart. I love how sweet and curious this gorgeous boy looks here, plus his little white hand is too cute to handle.

Adult male rat. Black Irish, Dumbo eared, standard coated.

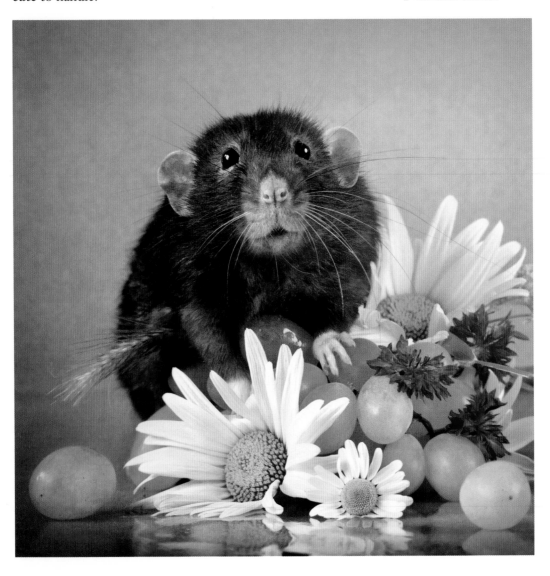

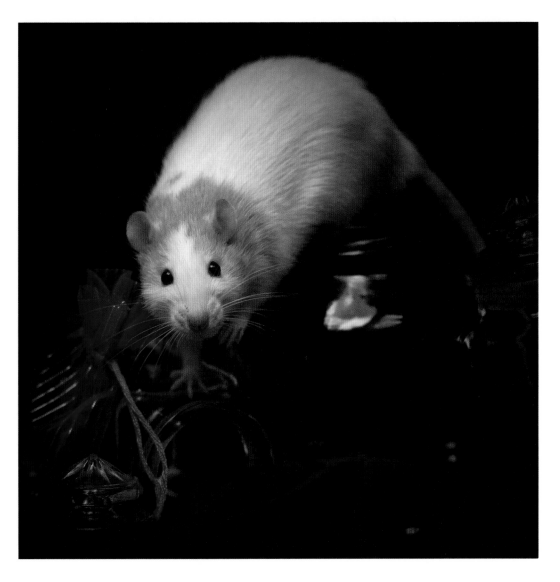

Odin

I fostered Odin and his brother, Máni, after they were rescued. These poor boys suffered from extreme malnutrition and were nearly as small as six-week-old baby rats, though they were almost seven months old. They were quite shy, but their curiosity was much stronger than their fears. Fresh food helped, too. These two soon became big and very playful, and they loved nothing more than getting cuddles after having spent a long afternoon exploring their surroundings. Odin was adopted by Emeline, along with Seth. He was absolutely adorable.

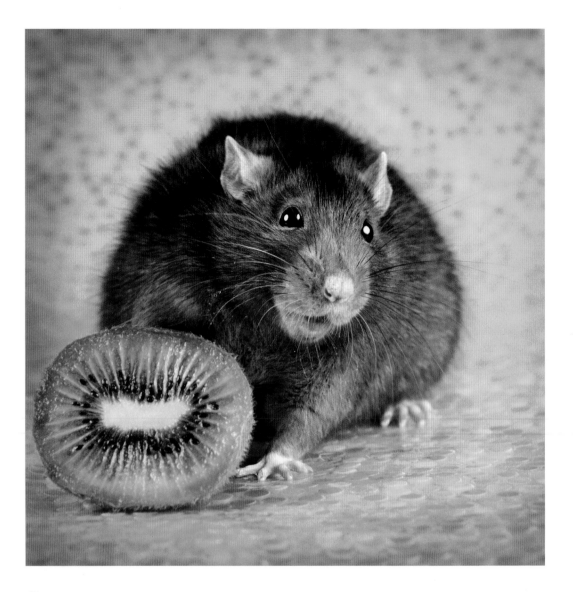

Onyx

As I had to photograph lots of small mammals to illustrate the
"Pavillon Rongeurs" of the annual animal fair, Animal Expo, in
Paris, my friend, Lyka, brought me all her rats for a photo
shoot. At that time, I had the pleasure to create this photo of
this big, adorable girl. She was very expressive, and I think she
would have talked with us if she could. She had the softest fur,
with an amazing reflective quality, so her name was very fitting.
I had a lot of fun photographing her and Lyka's other rats.
They were adorable.

Adult female rat.
Black Irish,
standard eared,
standard coated.

Feirefiz

Here is my perfect little model, Feirefiz, again. He sure knew how to look incredibly cute (he was even more adorable in real life, of course), and his color was the perfect excuse to take some pictures of him in a little pumpkin. However, he was much more interested in me than in the pumpkin, and he spent most of the shoot jumping onto my lens to climb atop my head and play with my hair. I ended up getting one of my favorite shots ever, though—and an absolute tangled mess of a hair on my head.

Baby male rescue rat. Fawn Hooded, standard eared, standard coated.

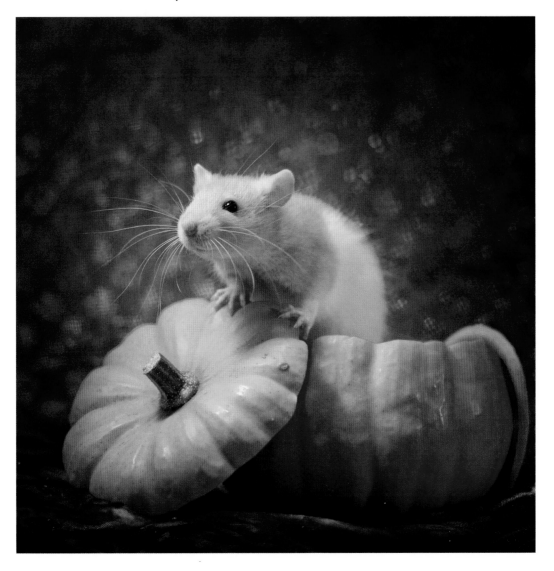

Lorich

If you are wondering how I got this ray of light, here is a very simple trick: for this shot, I used a large sheet of paper rolled into a cone, and a flashlight, plain and simple. Lorich was quite interested in that strange device and struck some amazing poses. This one is a perfect depiction of his very curious behavior. However, he soon decided that this weird light installation had become perfectly familiar and fell asleep on the pomegranate. His fur remained stained with some pink polka dots for some days. He was a very fancy rat!

Adult male rat from a rescue litter. Seal Point Siamese Hooded, standard eared, rex coated.

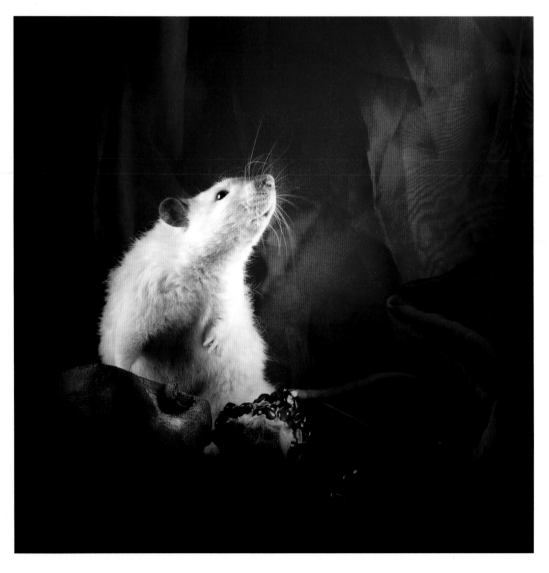

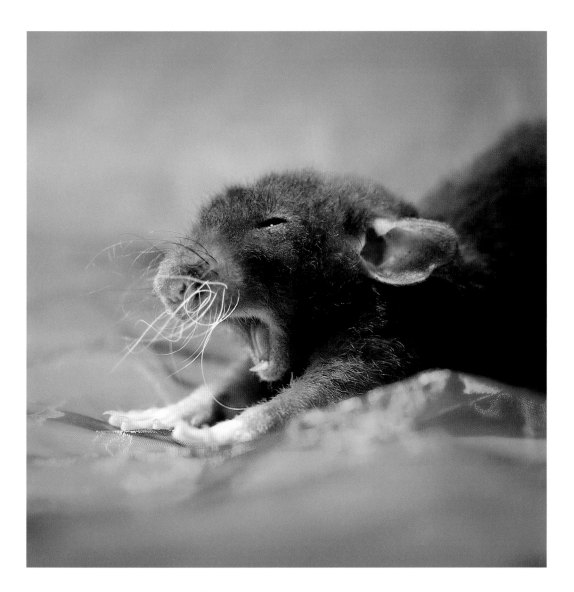

Arkanys

Young male rat from a rescue litter. Black Irish, Dumbo eared, rex coated.

This is my most well-known shot to date, which got me a lot of praise from many rats lovers from all around the globe. However, this was a very lucky shot, and all the credit goes to my adorable Arkanys, who tended to yawn a lot and fall asleep during most of our shoots. He began to feel quite at ease in my mini photo studio, and used to take long naps there. I had adopted him less than three weeks before this session, but he quickly proved himself a star.

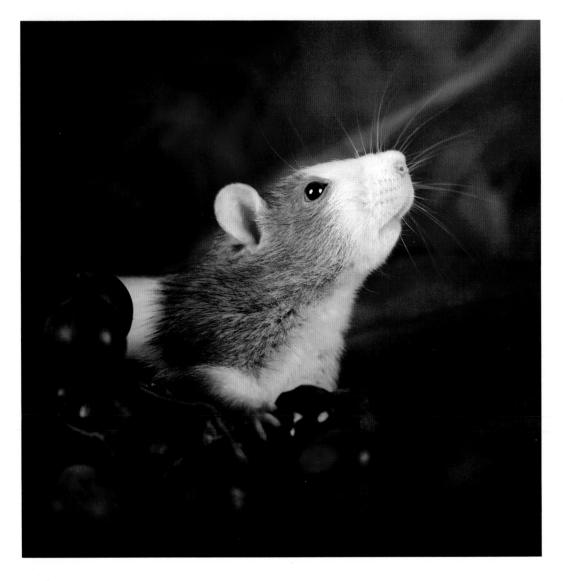

Máni

Máni was the smartest rat I have ever met. He was able to anticipate human emotions and to communicate in a very specific way, through complex gestures and mimicking. Despite his very rough first seven months of life (he was Odin's brother and shared the exact same terrible story), he became incredibly trusting and showed unconditional love. I could not bear the idea of letting him go, as I had grown very attached to him, so he stayed home, where he found his very best friend, Feirefiz.

Adult male rescue rat. Agouti Hooded Wedge-Blazed, standard eared, standard coated.

Aubade

Aubade was abandoned by her young owner, who had adopted a ferret and did not want his rat anymore. The owner's mother brought her to the vet, hoping that he would put her to sleep, but the vet refused and called me, asking if I could take her home instead. I accepted, of course, and totally fell in love with this big girl. She was incredibly sweet and cuddly and would spend hours sleeping on my shoulder. However, as I had only males, I could not keep her. She was adopted by my friend, Céline, who loved her very much.

Senior female rescue rat. Agouti Roan, standard eared, standard coated.

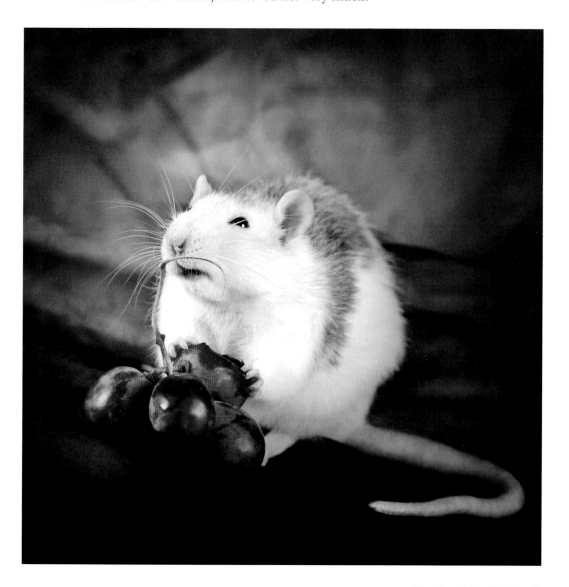

Kihara

I had the chance to rat-sit Kihara (as well as Dioné, Dotty, Wyfar, and Aaricia) during my friend Bluehorse's vacations. Kihara was a very gentle rat who very much enjoyed getting her cheeks scratched and was surprisingly calm for a female, both due to her older age and natural temperament. She acted more like a male rat, and I took advantage of her quiet behavior to put a flower atop her head, as I knew she would not toss it off right away. The flower placement almost woke her up and resulted in this cute, yet ridiculous, pose. She then went back to sleep.

Senior female rat from an unplanned litter. Agouti Hooded, Dumbo eared, rex coated.

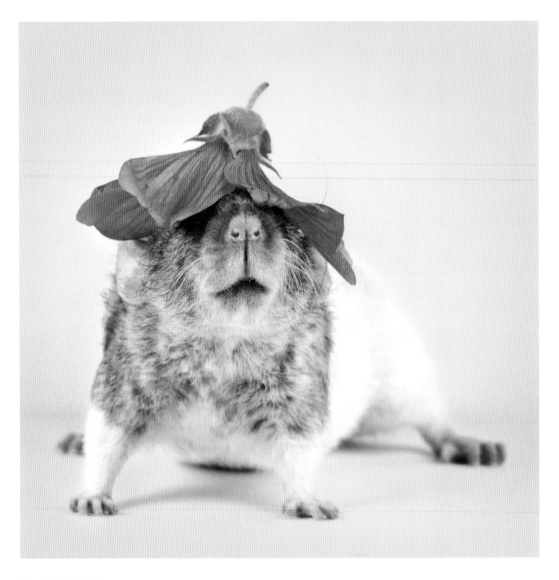

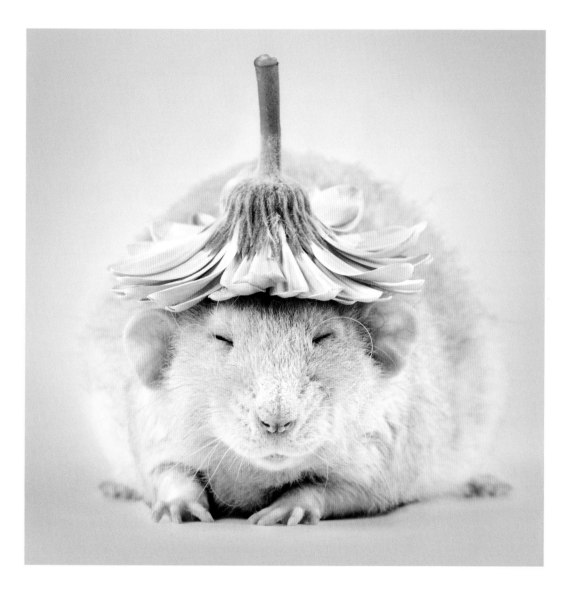

Herjan

*Adult male rat.
Russian Silver Irish,
Dumbo eared,
rex coated.*

Remember how peaceful Herjan looks on the cover image, using a Gerbera daisy as a pillow? Here he is again, photographed two days later, wearing that same flower as a very fancy hat. Herjan was the essence of serenity and the only rat I never managed to photograph with his eyes fully open. He had the ability to fall asleep anywhere, as long as he got some cheek scratches and cuddles. Though most rats are pretty active and very hard to photograph, I never had that problem with this sweet boy, whom I nicknamed "the Cloud," due to his fluffy look!

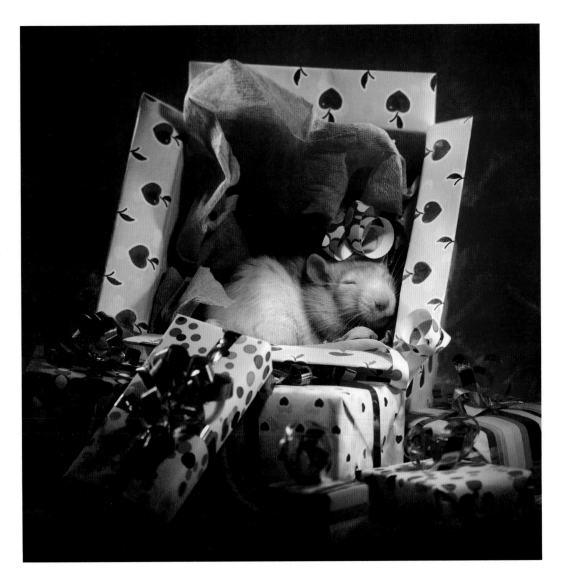

Feirefiz

Sleeping or digging in a box has always been one of the favorite activities of all the rats I have known. Feirefiz did both on this occasion. After finding all the hidden treats in this box, he just laid there and took a nap. This was too cute to handle, and while I had planned to take some more active pictures of him, as he was a very playful and interactive rat, this photo shoot turned out much better than expected, thanks to his sudden laziness. This picture melts my heart every time I look at it and brings forth a lot of awesome memories. He truly was a special rat.

Baby male rescue rat. Fawn Hooded, standard eared, standard coated.

Liola

Double-rex coated rats shed their fur very often and sometimes have bizarre molts. This one was especially funny, and while this adorable girl was perfectly healthy, I had a shock—and a good laugh—when I first met her. However, Liola was so playful and cute that I soon forgot about her funny appearance and totally fell in love with this sweet little lady.

Liola was Nastia's sister, Herjan's mother, and Dellingr's grandmother.

Adult female rat. Agouti Hooded, Dumbo eared, double-rex coated.

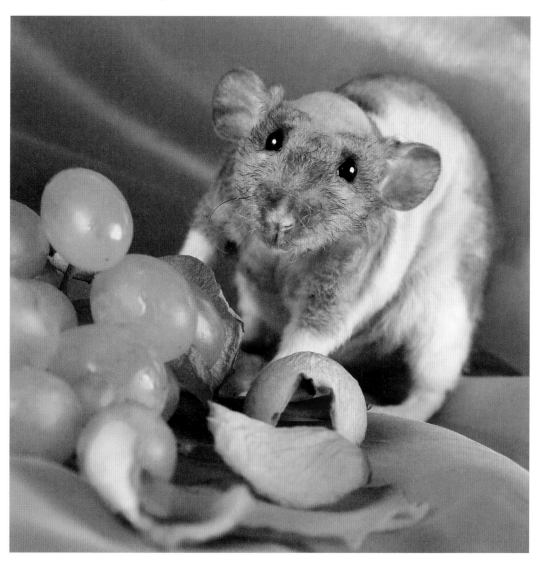

Fenrir

I often had fun painting faces on vegetables and pretending rats were gigantic monsters ready to eat them. This shot was part of that absurd series, and Fenrir seemed to read my mind when he suddenly stood on his hind legs. My little clown was the best when it came to action "poses," and this one is no exception.

Do not be fooled by the fact Fenrir actually seemed to pose: it did not last for more than a second. With experience, I learned to anticipate rats' movements when shooting.

Adult male rat from a rescue litter. Agouti Irish, standard eared, rex coated.

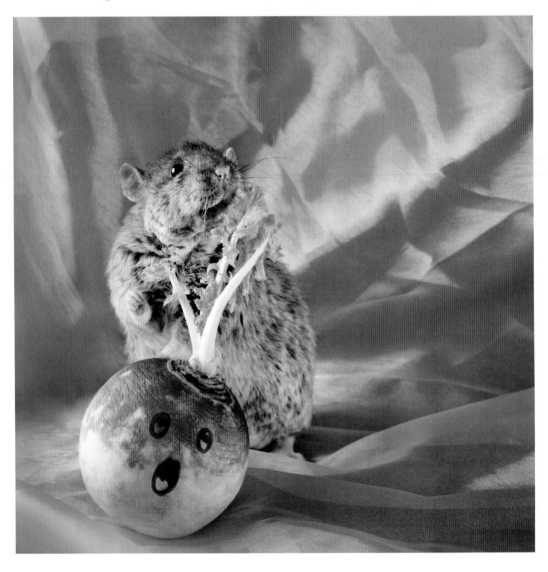

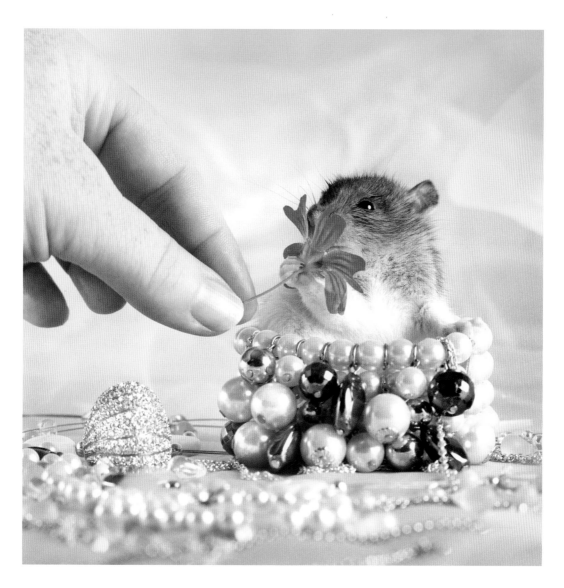

Pilgrim

Baby male rat from a rescue litter. Agouti Hooded Headspotted, standard eared, standard coated.

I had offered to take pictures of the babies in a rescue litter my friend, Udine, was caring for, to help them find good homes. I never expected to capture such an incredibly sweet moment. Udine was handing Pilgrim a Malva Sylvestris flower, as he seemed quite intrigued by it, and he gently grabbed it with his little hand and started smelling it. (Of course, he tried to eat the flower first, as most baby rats will, as they learn about their surroundings. It was absolutely safe, as this is an edible flower.)

Pilgrim was Melehan's brother.

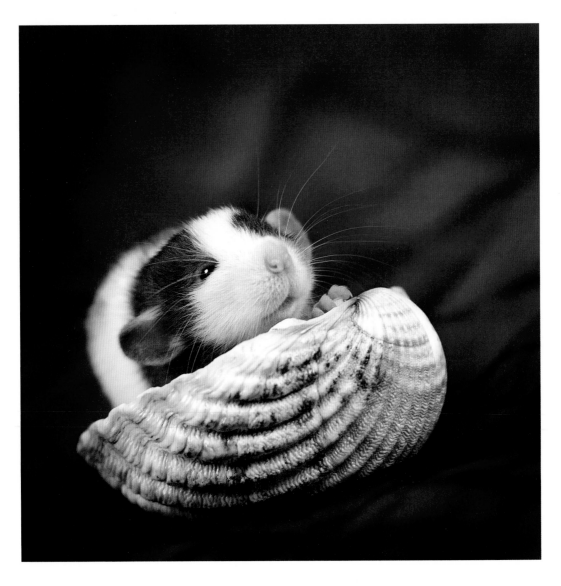

Taz

Sail, little pirate, sail! Taz was Gareth's brother, and this picture was taken the same day as the one with Gareth looking incredibly small in a human hand. Taz was quite small, too, and fit nicely into this seashell, which looked like a tiny boat. As I had some blue fabric on hand, I thought it would be nice to make some marine-themed pictures, and this one came out really cute. Who can resist this sweet face?

Baby male rat.
Black Variegated Blazed,
Dumbo eared,
standard coated.

Lapsang

This is one of the shots that did not make it into the rat-themed calendar I did with my friend, Tiphaine. However, I really like the various shades of brown here, and Lapsang was quite photogenic, to say the least. This gorgeous boy seemed to be slightly stressed by the unfamiliar surroundings and new smells, and he acted a bit shy. We quickly snapped a couple of pictures and let him go back to his owner so he could feel safe again. Surprisingly, our images of Lapsang turned out great, despite the fact that he quickly hid behind the fabric.

Adult male rat. Cinnamon Irish, Dumbo eared, rex coated.

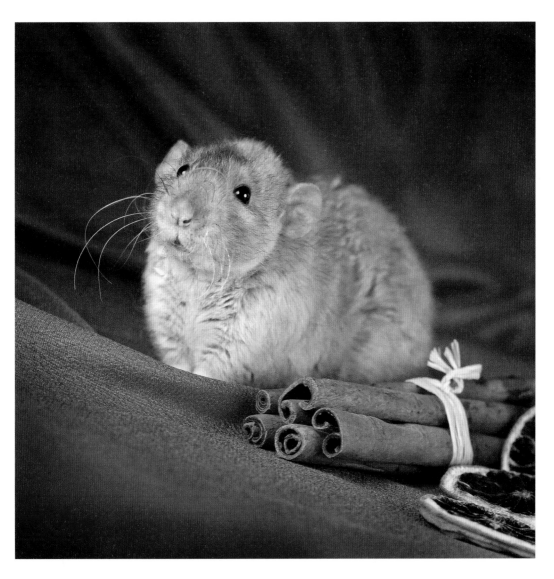

Face Qui Rit

This photograph was taken the same day as the picture of Willy Wonka *(see pages 12–13)* and the one of Hephaïstos le Rat *(page 58)*. Face Qui Rit, a.k.a. Kiri, was a gorgeous big boy, sweet and funny, and I was able to take some nice pictures of him despite the fact he was quite active. He was not a bit stressed by the camera and proceeded to eat as many grapes as he could and beg for some cuddles.

I really had a great time with these lovely rats. They had great personalities.

Adult male rat. Amber Self, standard eared, standard coated.

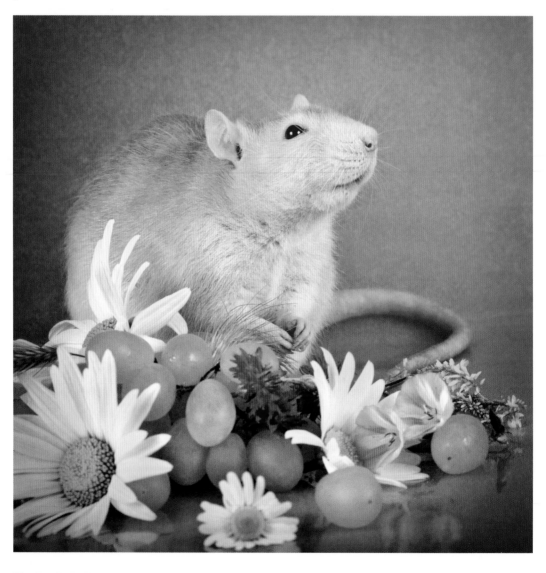

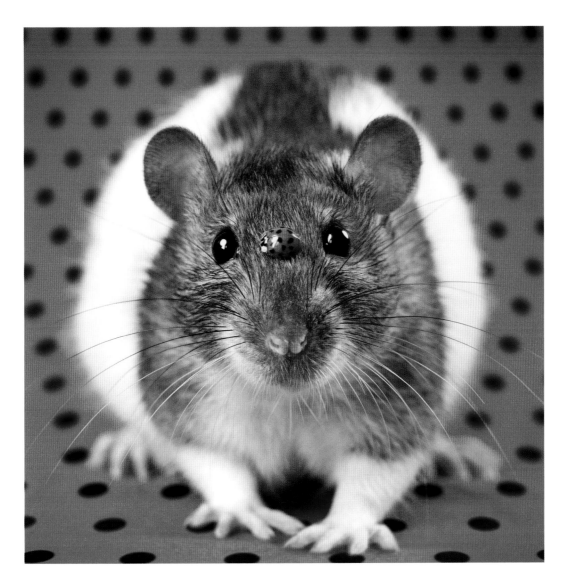

Kjalarr

Young male rat born from a rescue litter. Agouti Hooded, standard eared, standard coated.

My rats were roaming free in my apartment one summer when a ladybug flew in through an open window. As it landed on Kjalarr's back, it instantly reminded me of the red paper sheet with polka dots from my photo backgrounds collection. Thus, I quickly grabbed Kjalarr and put him in my mini-studio. The lights, fortunately, were already set up from an earlier shoot. I gently pushed the ladybug onto Kjalarr's face and took a couple of pictures before the ladybug unfolded its wings and legs and flew away. Kjalarr remained standing still, hoping for treats.

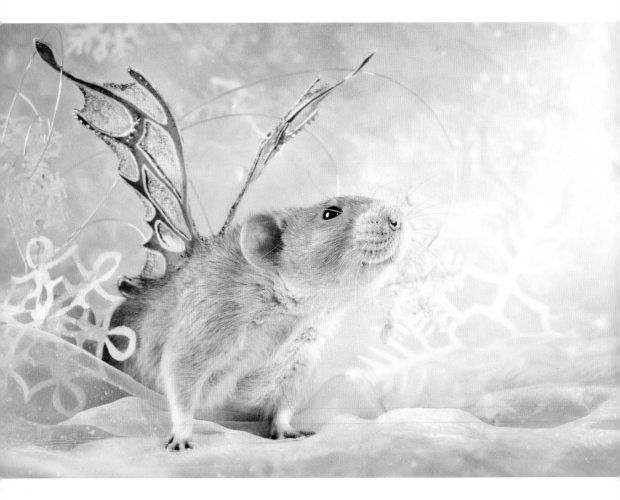

Lysander

I took this picture for a "winter fairytale" themed competition. I crafted the little wings out of two plastic sheets (a heavy one and a thin transparent one), glittery nail polish, and gold paint. These were attached to a small piece of metallic thread, molded to fit Lysander's back so he could just shake them off when he wanted. I also crafted the snowflakes and basically the whole scene, using translucent fabric, colored lights, glass beads, and powdered sugar to achieve this wintry look. Lysander was extremely gentle, and happy to get cuddles, as usual.

Adult male rat from a rescue litter. Lavender Agouti Irish, Dumbo eared, standard coated.

Niobé

The sweet Niobé was quite hyperactive. As such, this is some kind of a miracle shot I thought would never happen, especially with her being such a playful rat. All it took was playing with a rain stick: she was not used to that noise, so she stopped moving for a second, before deciding it was too intriguing not to get closer to it.

Adult female rat. Russian Blue Agouti Irish, Dumbo eared, rex coated.

Making some unusual sounds, as long as these are neither loud nor scary, or introducing a less familiar treat, such as blueberries, to get a curious rat's attention can be a useful trick!

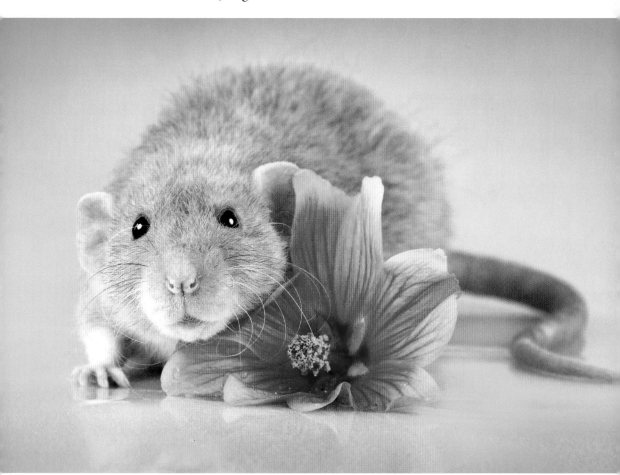

Thorim

Thorim had two passions in life: sleeping (as you can see in the picture where he uses a Jack-Be-Little pumpkin as a pillow) and eating banana. He was obsessed with banana, and I knew for sure that I would get more dynamic poses if I were prepared with a bowl full of bananas. This went exactly as I had planned and Thorim, for once, did not immediately fall asleep in my mini photo studio. Instead, he started stealing all the banana bits and stacked them behind the large sheet of paper I used as a background.

Adult male rat born from a rescue litter.
Seal Point Siamese Hooded, standard eared, velveteen coated.

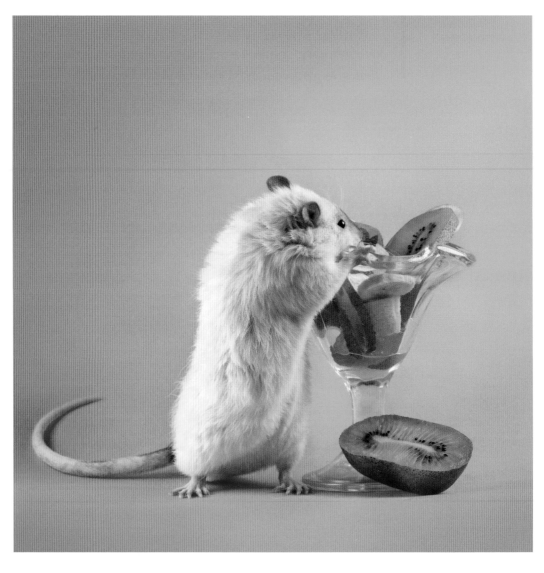

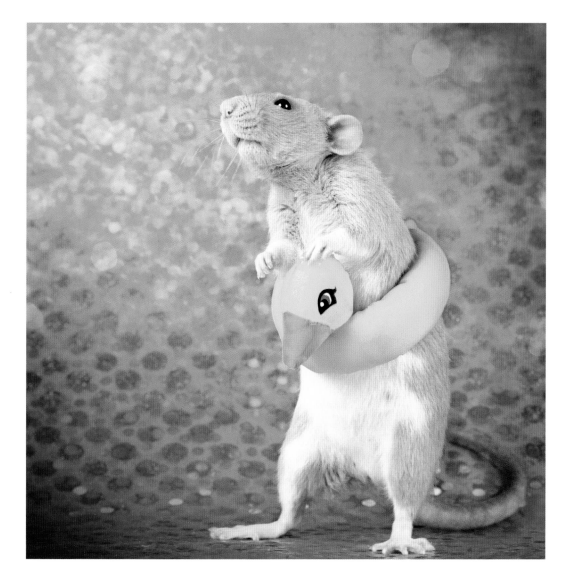

Yuko

Adult female rat.
Russian Blue
Burmese Berkshire,
Dumbo eared,
velveteen coated.

Two years after working on the first rat-themed calendar, I took part in the making of another one. I was tasked with illustrating the month of August with a photo that would make people want to jump into a swimming pool. As I took this picture during winter, I had to avoid bathing my little model, so I crafted a mini rubber ring instead. The prop was so loose, Yuko took it off a couple of times before I managed to get a decent shot, while her owner held treats above her head to make her stand up. She was an adorable, mellow girl and was duly rewarded.

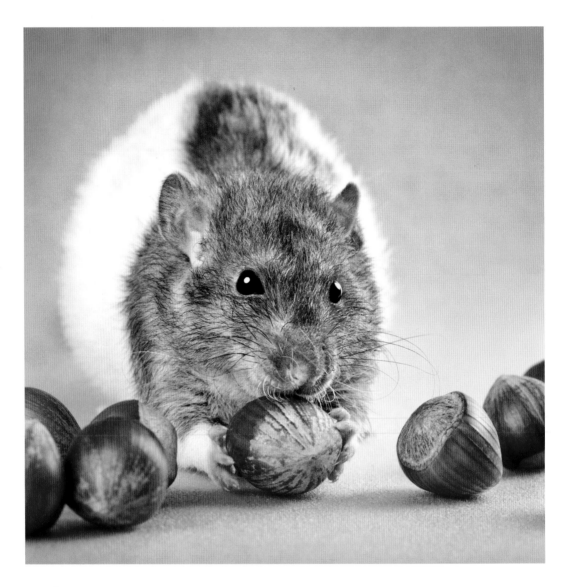

Grímnir

Rats have teeth that continually grow, and they need to use them daily to avoid dental overgrowth. Thus, I used to give them lots of nuts with their shells. Grímnir loved hazelnuts the most. He stole them all, and it was very funny to see him try to carry more than one hazelnut at a time while jumping obstacles to reach his favorite spot, and fail repeatedly. I felt quite sorry for him, but he eventually ended up collecting all of the nuts and looked very content.

Young male rat. Agouti Hooded, standard eared, rex coated.

Lysander

Beware the terrible strawberry killer! That strawberry sure did not stand a chance against my gentle giant. Lysander had a thing for apples and strawberries—and for food in general, to be fair. Every time I photographed him, I caught him making funny faces, trying to lick some fruit juice or to reach for the tastiest parts of some sunflower seeds. This picture is a perfect depiction of his funny behavior. I do not think I could have captured a more fitting image of him. He was absolutely adorable!

Adult male rat from a rescue litter. Lavender Agouti Irish, Dumbo eared, standard coated.

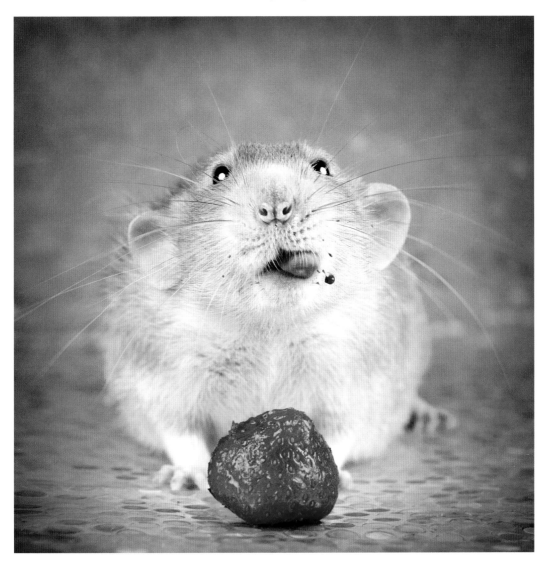

Inoa

Inoa was Feirefiz's sister. She was a sweet and delicate girl with elegant gestures, although she soon proved to be as clingy as the other rats from this family. I love how this picture turned out, as it suits her softness very well.

 Inoa was roughly five weeks old when this image was made, yet she already had that very particular head shape that almost all the rats from her family inherited (and are still inheriting to-day, generations later). She was adopted by Ju and lived happily for over thirty-two months, which is quite an old age for a rat.

Baby female rescue rat. Fawn Self, standard eared, standard coated.

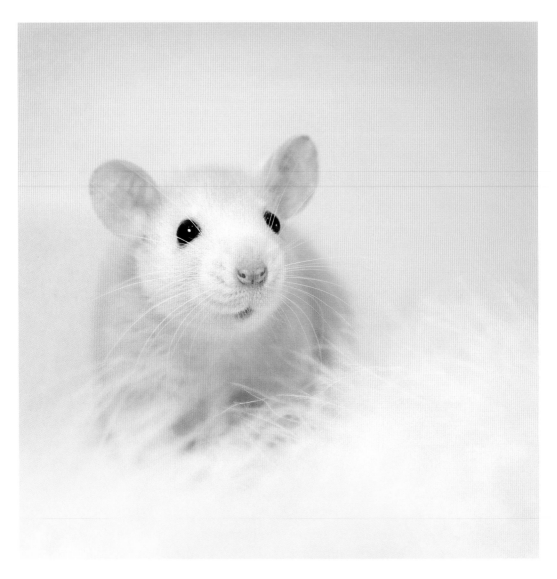

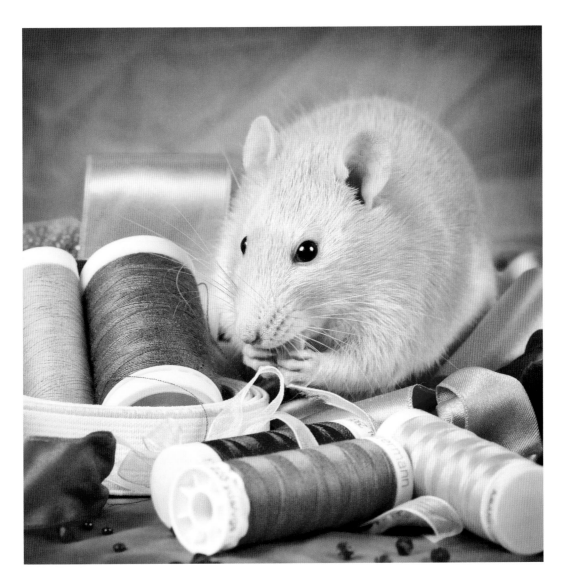

Svölnir

Young male rat.
Russian Fawn Variberk
(Variegated Berkshire),
standard eared,
standard coated.

Svölnir was Lillebjörn and Chlamydiae's son, and Grímnir's brother. He was a very smart and playful rat, whom I had nick-named "The Hyper Quantum Rat," as he was even more clingy than his father and grandfather. He would never stay still for more than a second, except when he was sleeping on my shoulder (which was his favorite spot) or when I gave him some corn flakes, which he was crazy about. He had fabulously soft fur and spent an insane amount of time grooming himself. He was the cleanest rat in the whole pack.

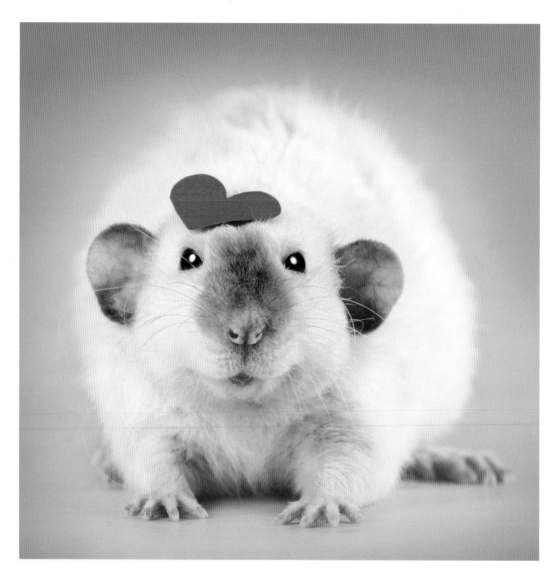

Kiran

Kiran was a sweet, shy little boy who had been adopted by my friend, Udine, but never managed to get along with her other rats and was almost killed by one of them. As my rats were very gentle with newcomers, Udine decided to give Kiran to me so he would not live alone. Despite being frightened at first, he quickly befriended the whole pack, especially Lillebjörn and Tjall.

This photo was taken for a Valentine's Day themed photo competition. Who wouldn't fall in love with such an adorable, smiling face?

Adult male rat.
Seal Point Siamese,
Dumbo eared,
rex coated.

Michelle

This is one of the December shots for the rat-themed calendar that was not selected for use. (I was only in charge of producing photos for six months out of twelve, but I still took part in creating photos for months that were not assigned to me.)

Adult female rat. Black Hooded, standard eared, standard coated.

Michelle was an adorable rat with very delicate gestures, and she seemed very intrigued by this little box. Though the box was empty, she tried to untie the ribbons to find out if there was some kind of treasure hidden inside.

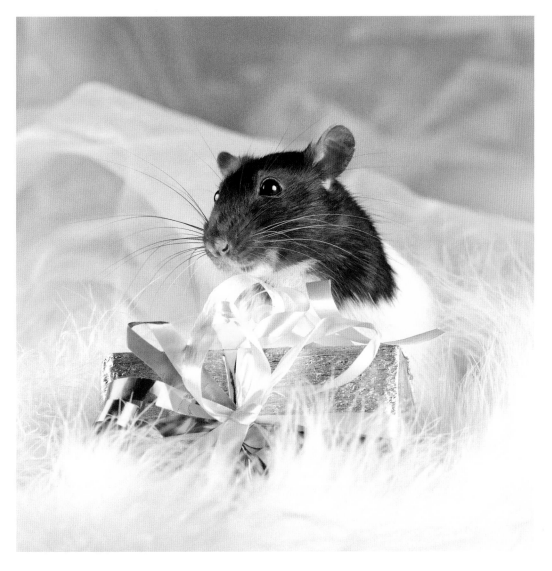

Chlamydiae

I took this shot a couple of days after Chlamydiae's arrival at home, as she was already perfectly relaxed. As you can see in this photo, and many of my other pictures, the background is a bit reflective: I learned soon enough to use book-wrapping plastic sheets on top of colored paper or fabric to avoid stains from the juices of the fruits and vegetables I give rats during photo sessions.

During our shoot, Chlamy quickly understood she was about to be offered a bit of fruit and patiently waited for it.

Adult female rat. Russian Fawn Irish, Dumbo eared, velveteen coated.

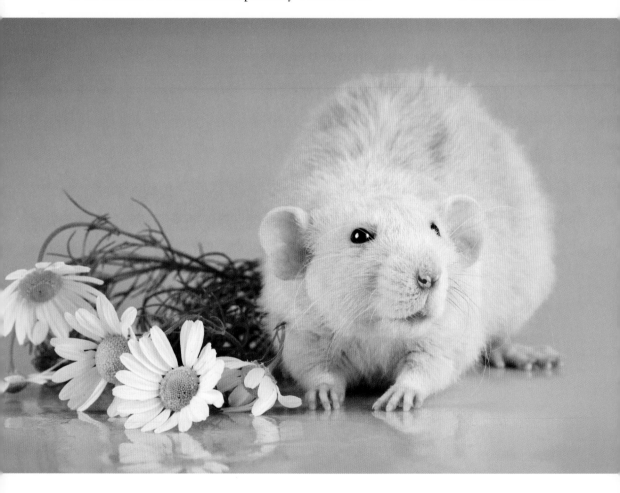

Vortimer

*Senior male rescue rat.
Black Roan,
standard eared,
velveteen coated.*

Vortimer and his brother, Hymir, were rescued by a friend of mine. They were sick and painfully skinny, so I took them into foster care, hoping to help them recover and find them a good home. However, the latter never happened: it was one of my biggest foster fails. I loved these two boys so much that I could never let them go and ended up keeping them. Despite being old and weak, they eventually healed and became very playful and cuddly. Vortimer was a total sweetheart and adored napping on my shoulders.

Kaelan

Kaelan was Lysander's brother, an adorable big boy who lacked a bit of gentleness when it came to grooming my hands, but was so eager to please me that I would pretend he did not hurt me at all. (He used to alternate between pinching and licking fingers, but would never let my hand go until it was fully clean, according to his taste.) He was able to jump a very impressive height and length, and his tendency to ignore danger allowed him to learn how to jump straight from his cage to my arms when I was passing by.

Senior male rat born from a rescue litter. Cinnamon Irish, Dumbo eared, standard coated.

Kissing My Song

Judging by the number of rats that I photographed with a flower atop their head, I think that might be my trademark, and I somehow feel that I was lacking imagination there . . . but have you ever seen anything as cute as this sweet baby with her flower? I have not.

Baby female rat. Black Berkshire, standard eared, standard coated.

Kissing my Song was the daughter of my adorable Feirefiz, and Lillebjörn's sister. She was very tiny when this image was captured and had just opened her eyes. I always thought she looks like a tiny mouse from a fairy tale in this picture.

Banksy

My friend, Chnou, brought me her rats for a photo shoot, and I could not resist photographing them with the tiny wings I had crafted a few days earlier. These were quite easy to remove, and the rats could get them off by shaking themselves. However, as it often goes with rats, food was a priority, and Banksy did not seem to mind the wings at all. He was much more interested in the drops of pumpkin puree I had put onto the small pumpkin, and I was lucky enough to capture him licking it, which made for a very mischievous expression.

Adult male rat. Agouti Irish, standard eared, standard coated.

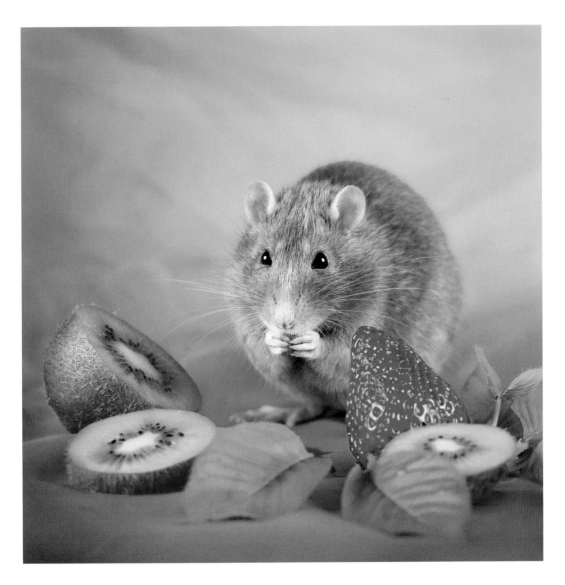

Blue Suede Shoes

Adult female rat.
Russian Blue Irish,
standard eared,
standard coated.

I had the chance to rat-sit Blue Suede Shoes during my friend Limë's vacations, and I fell in love with that adorable girl. She had the sweetest expressions and looked stunning. She was actually grooming herself when I took this picture, but I love how she seems to hesitate between the kiwis and strawberry. This is a good example of how setting a high shutter speed can make rats look very calm, while they are in fact quite active and not actually posing at all. Needless to say, these nice-looking fruits were soon devoured!

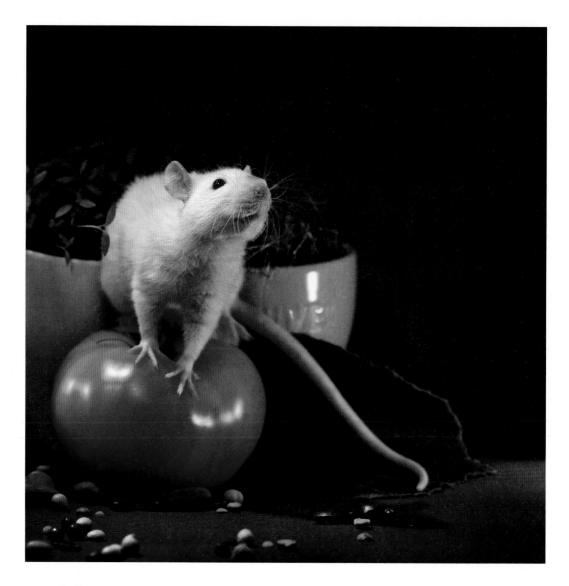

Lorich

Look at this proud baby standing on a tomato! Was he able to better see things from this elevated position? I do not think so, as rats have poor vision, but he sure looked proud of himself.

For this shot, I sacrificed my homegrown herbs, as Lorich decided to dig into the chives and parsley pots, which did not survive his excavations. However, it was quite worth it; I love how this picture turned out, as well as the joy that Lorich seemed to feel while exploring his surroundings.

Baby male rat from a rescue litter. Seal Point Siamese Hooded, standard eared, rex coated.

Messire James

My friend, Babbou, brought her rats to my home so we could photograph them with our mutual friend, Tiphaine, to get enough photos for our exhibition at Animal Expo. We had a lot of fun decorating my mini photo studio together, trying to create the perfect surroundings for each rat. Messire James was seemingly quite happy with our choices. He immediately spotted the grapes and did not even dare exploring, as he was much more interested in the juicy fruit. He was adorable and had really great expressions.

Senior male rat. Burmese Hooded, standard eared, standard coated.

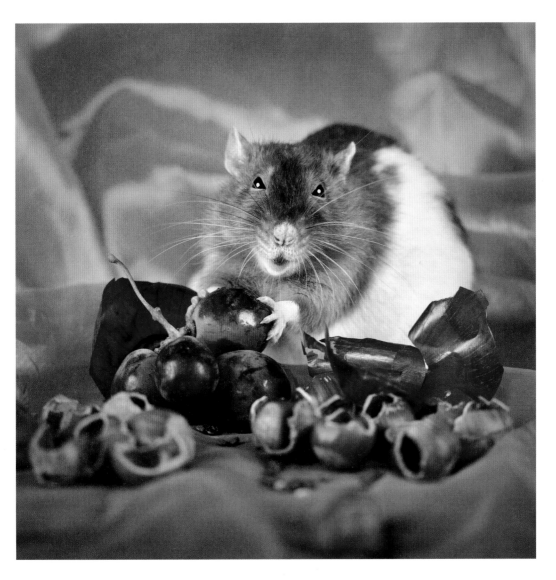

Arkanys

I loved to capture Halloween-themed pictures that went against the usual standards and depicted cute and funny rats instead of the nasty-looking ones that are often shown at that time of the year. Arkanys could not have been a better model, with his big, shiny eyes, and adorable pink nose and ears. I was very pleased with how this picture turned out, despite the lack of proper lighting. Back then, I took pictures using only multiple desk lamps and a piece of paper or fabric taped to a wall as my mini-studio background.

Young male rat from a rescue litter. Black Irish, Dumbo eared, rex coated.

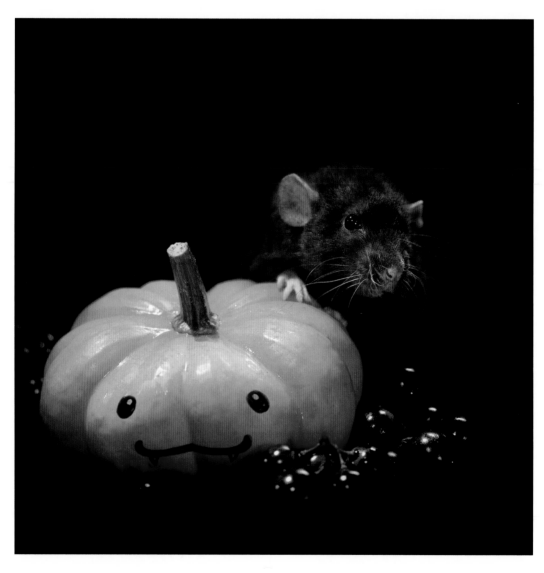

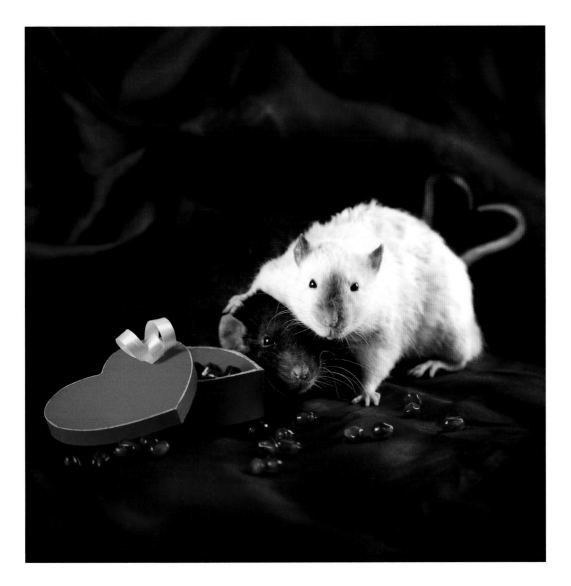

Arkanys & Lorich

Adult male rats from rescue litters. Black Irish, Dumbo eared, rex coated, and Seal Point Siamese Hooded, standard eared, rex coated.

This is the trickiest picture I have ever taken. It involved over three hours of patience, lots of cooked pasta, pomegranate, plenty of cuddles and cheek scratches and, of course, ninja reflexes. I felt that the homemade heart-shaped box was not cheesy enough and spent a lot of time petting my sweet boys to get them to almost fall asleep so I could arrange their tails into this heart shape. Of course, they woke up as soon as I stopped petting them to beg for more, and I had to start all over again. This was a very lucky shot!

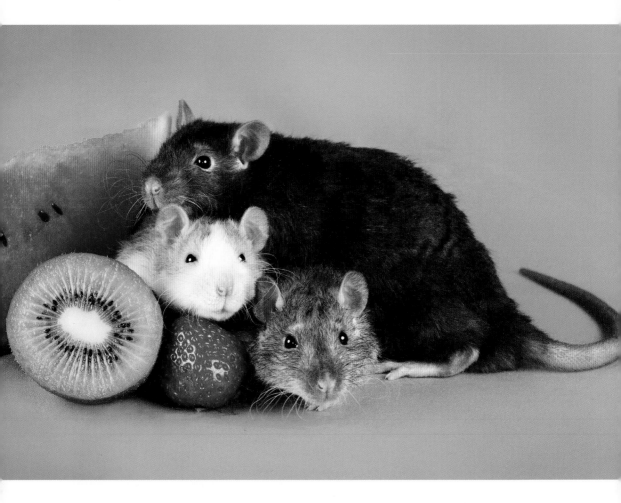

Wait for It, Bifrost & Lillebjörn

What is harder to get than a picture of a rat standing still? An image of three rats standing still, of course. These three brothers were especially playful, and I still am very surprised I managed to get such a photo, with the three of them looking in my direction and in focus. They were about seven weeks old then, and while Bifrost had pitch-black markings when he was a baby, they had, by this time, faded a lot (this is normal for Roan rats), and he ended up being almost pure white later on.

Young male rats.
Black Irish,
Black Roan, and
Agouti Berkshire,
all standard eared,
rex coated.

Pocket & Jack

These sweet babies were my Feirefiz's siblings. I had brought some jewelry pockets when I went to photograph them at my friend Tiphaine's house, and they were so tiny they fit into them. They seemed to enjoy staying there very much and fell asleep, making for one of the cutest pictures I have ever taken. I wish the lighting conditions had been better, but I still managed to get the rats' eyes and noses in focus, and to capture their adorable expressions.

Baby male rescue rats. Agouti Hooded, standard eared, standard coated, and Albino, standard eared, standard coated.

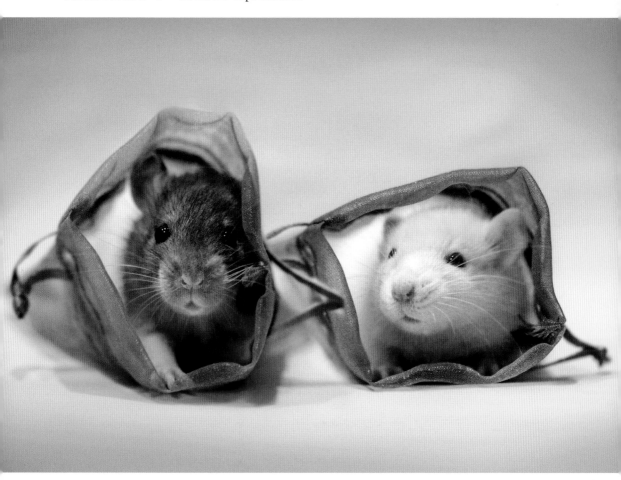

Njörd

Njörd's mother was abandoned at a vet's office when her owner found out her pet was pregnant and decided she did not want to take care of the litter. The pregnant rat was rescued by my friend, Udine, and gave birth to fourteen babies some days later. Once again, I fell in love during a shoot intended to help find good homes for the babies. Njörd was the fourth rat I had adopted of those Udine was fostering, and I did not regret it a bit (not that I ever do!). He was one of the most playful rats ever, and absolutely adorable.

Adult male rat from a rescue litter. Beige Hooded, standard eared, hairless.

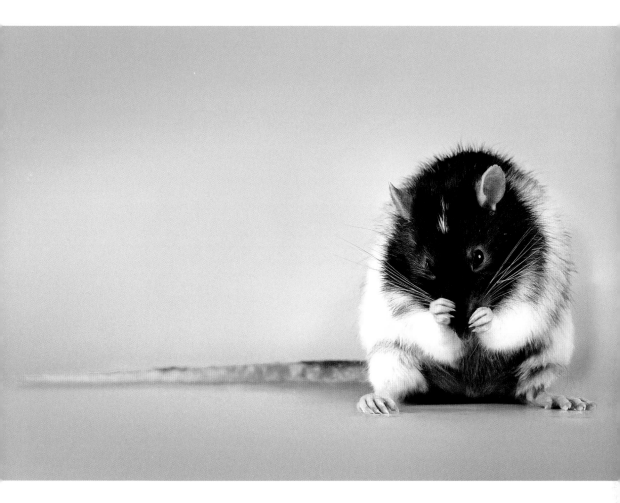

Sensei

I was tasked with photographing this adorable rat, which was not easy, as he used to be very active according to his owner, Shansian, but only wanted to get cuddles during the shoot. He was very sweet, and I could see the bond he had formed with Shansian, as he became immediately relaxed when she talked to him. I finally managed to take some action shots, although none of the expected "meerkat pose," as Sensei much preferred napping. Shoots don't always go as planned, and rats should never be forced into "posing" if they do not want to.

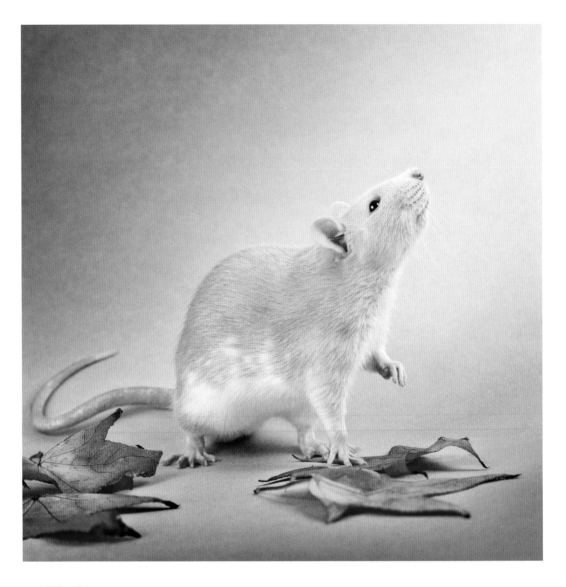

Svölnir

Have you ever seen such an elegant rat? The very curious
Svölnir spent a lot of his time sniffing the air, which resulted in
some dynamic poses I liked very much. I was especially pleased
with this one, and amazed at how strikingly similar he looked to
his grandfather, Feirefiz. Both had the same facial structure and
attitudes; Svölnir was just a tiny bit smaller. This image is the
result, again, of the magic of a high shutter speed coupled with
some good reflexes, as he was jumping into the air to reach my
camera a couple of seconds later.

Young male rat.
Russian Fawn Variberk
(Variegated Berkshire),
standard eared,
standard coated.

Lillebjörn

I was tasked with creating some fairy-tale inspired pictures to illustrate a rat-themed desk diary, and this one was supposed to be a genie coming out of a lamp. I used colored lights (a red one and a light-blue one), a large piece of black tulle with glitter to achieve a starry night look, plus copper and brown organza, and a painted background. This image turned out surprisingly well. I was quite pleased with the magical atmosphere I managed to get, and my sweet Lillebjörn had a great time enjoying the pomegranates.

Adult male rat. Agouti Berkshire, standard eared, standard coated.

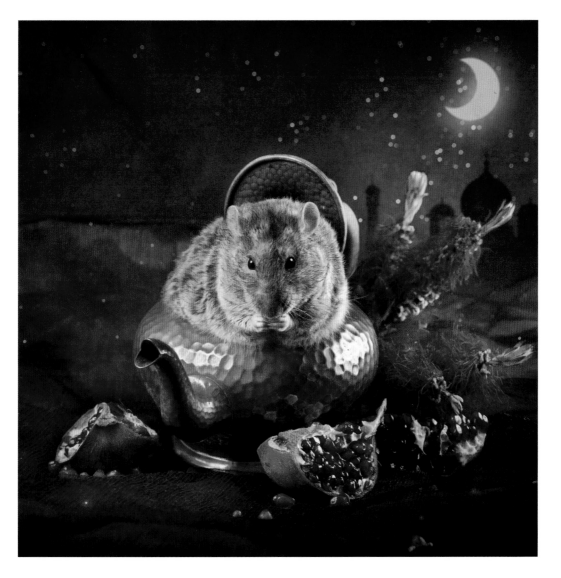

Niobé

Sweet Niobé was Chlamydiae's sister and Svölnir, Bachi, and Grímnir's aunt. This adorable girl knew how to melt my heart, and I was sad when the shoot was over and she had to go back to her home. However, I had the chance to take some sweet pictures of her, which remind me of the good times I spent playing with her. She used to rush at me, plow into my hands, and wait for me to push her back just to repeat it all over again. She had that typical "let's play right now" look when I took this photograph.

Adult female rat. Russian Blue Agouti Irish, Dumbo eared, rex coated.

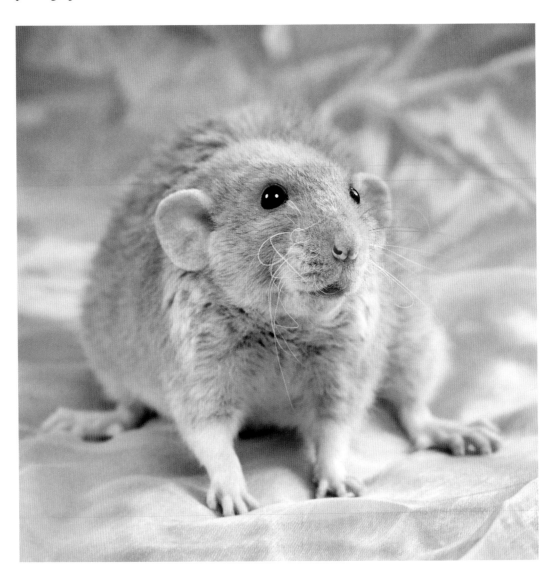

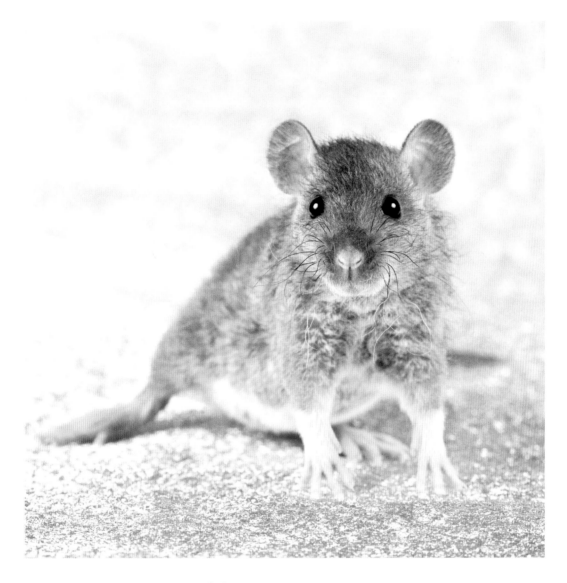

Bachi

Baby male rat. Agouti Irish, standard eared, rex coated.

Bachi was Svölnir and Grímnir's brother, an adorable rat who was particularly vocal and would squeak for absolutely no other reason than the sole happiness of making some noise. He was very curious and playful, and looked very much like his father, Lillebjörn. I used a large sheet of crumpled foil-coated wrapping paper as a background for this picture. This proved very useful, as it helped to bounce light back onto my subject and, with the extra light, I was able to choose camera settings that allowed me to avoid and getting blurry pictures.

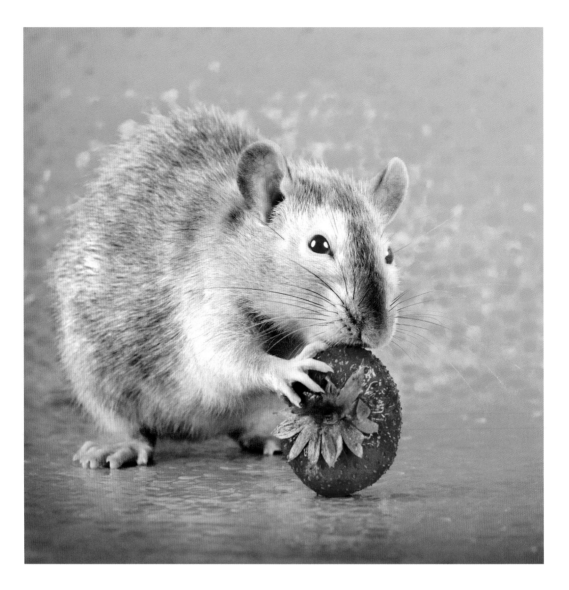

Cycomore

This precious little doe belonged to my friend, Lyka, who had adopted her when her owner could not keep her anymore and had to rehome her rats. She was quite sweet and instantly felt at ease during this shoot, though she had never met me before. Marten rats, also called "Red Eye Devils," are born fully colored, then their color begins to fade as they age, similar to Roan rats. They have a very distinctive look, and this girl sure was quite stunning in addition to being adorable.

Adult female rat. Black Marten (Red Eye Devil) Self, standard eared, standard coated.

Lothar

Despite looking like he was plotting something in this picture, Lothar would never have been a good villain in real life. He was just too sweet and too mellow-tempered to be taken seriously by even the tiniest rats, and although he tried to become the leader of the pack a couple of times, he never succeeded. He was, instead, the kind of rat all the youngsters befriended right away. I loved this old rat very much! As usual, this image was the result of setting a high shutter speed, along with using some strong light sources.

Senior male rat. Black Mismarked Capped Headspotted, standard eared, velveteen coated.

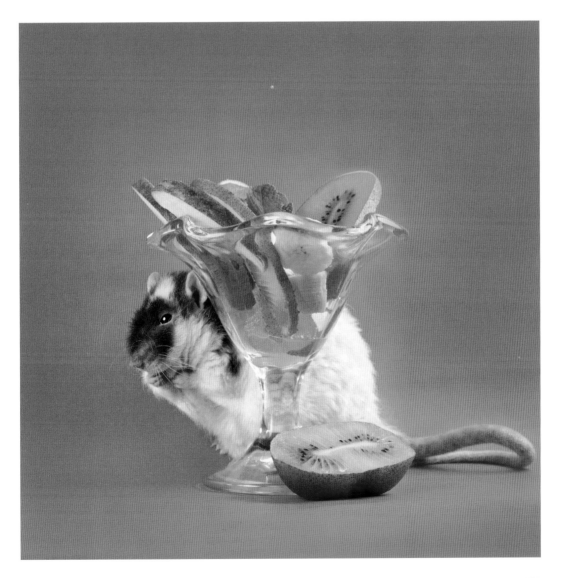

Arkanys

That perfect round cabbage in my fridge was too good looking
not to be used as a prop for a photo shoot. And what is better
than a perfect round cabbage with a perfect chubby and fluffy
rat on top? Arkanys, fortunately, was not that fat in reality, but
certain angles and poses can make rats, especially Rex ones, look
quite chubby. This might be one of my favorite shots to date,
as I absolutely love how Arkanys almost looks like one of the
Susuwatari from Miyazaki's movies.

*Adult male rat from
a rescue litter.
Black Irish,
Dumbo eared,
rex coated.*

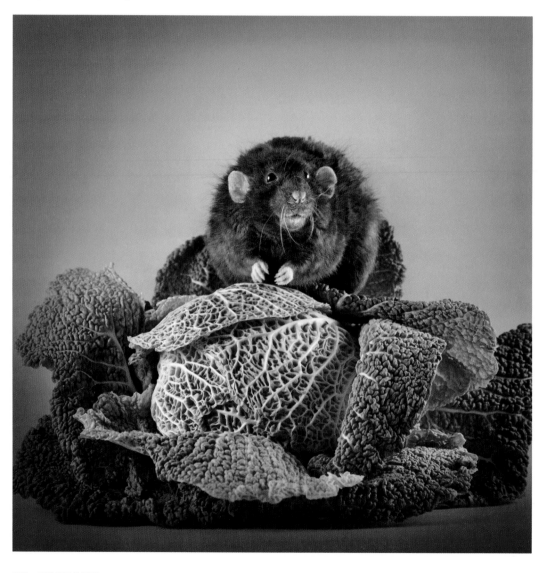

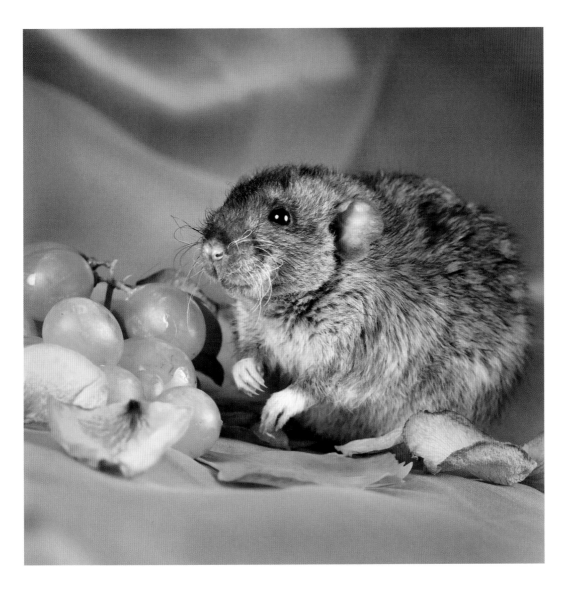

Nastia

Adult female rat.
Agouti Irish,
Dumbo eared,
rex coated.

Nastia was Liola's sister and Herjan's aunt. This picture was a rejected shot from the rat-themed calendar, yet I love it very much, as I feel there is a nice color harmony, plus Nastia's pose is quite cute. Nastia and her sister, Liola, were both very sweet and playful girls, and not a bit shy. They both started exploring the mini photo studio right away when their owner, Manzelle, brought them to my home for the session. It was a pleasure to work in such conditions, and the rats and I had a great time.

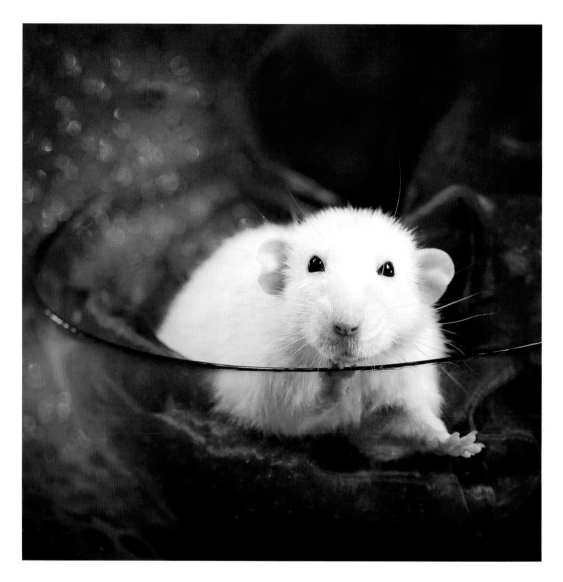

Bélial

Bélial came from the same rescue mission as Seth and Thor. He was quite weak and overweight when I took him home. He had never had the opportunity to develop his muscles, as he had spent his life in a very small cage. I had to figure out a special diet for him and get him to swim in a small tub twice a day to help him regain strength and control over his movements. He was so adorable I could not let him go, though I had initially planned to find him a good home.

Senior male rescue rat.
Black Roan,
Dumbo eared,
standard coated.

Dellingr

Dellingr's absolute cuteness was perfectly fitting for a Valentine's Day themed photo shoot. He had a face that was both grumpy and sweet and could melt anyone's heart, but it was hard to get decent shots of him, as he was always rushing toward me to get more cuddles, while I was hoping he would stay in my mini-studio. Dellingr's favorite thing was to crawl onto my arm, rest his head on the inside of my elbow, and stay there for hours, waiting for me to pet him and scratch his cheeks. How adorable!

Young male rat. Fawn Self, Dumbo eared, rex coated.

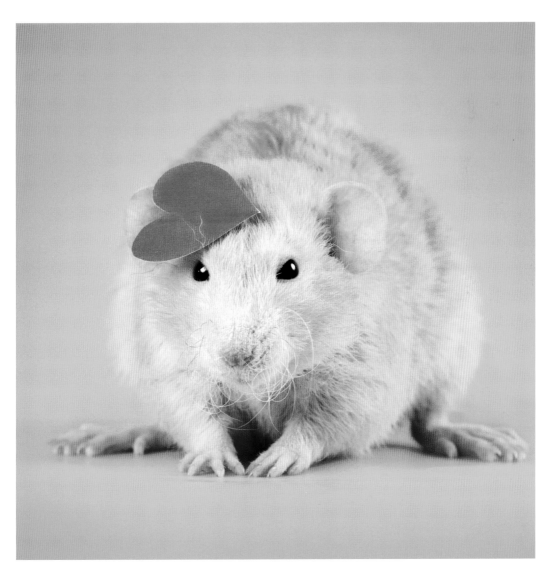

Tjall

My rats were so used to photo shoots that they eventually learned how to manipulate me, and Tjall was no exception. He would sometimes stand on his hind legs, as he did in this image, and soon noticed that I liked photographing him when he did so. He ultimately began to stand as soon as I started photographing him, and waited for his reward. This image depicts Tjall doing what he did best: acting cute, hoping to get some treats. Needless to say, he was quite a smart little boy!

Adult male rat.
Russian Blue Wheaten
Burmese Irish,
standard eared,
velveteen coated.

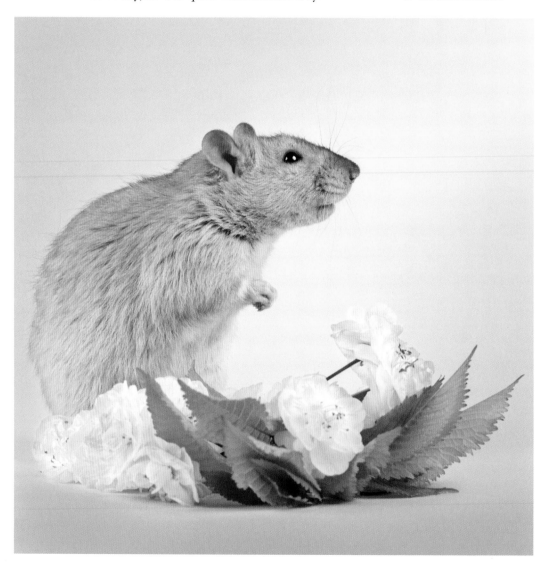

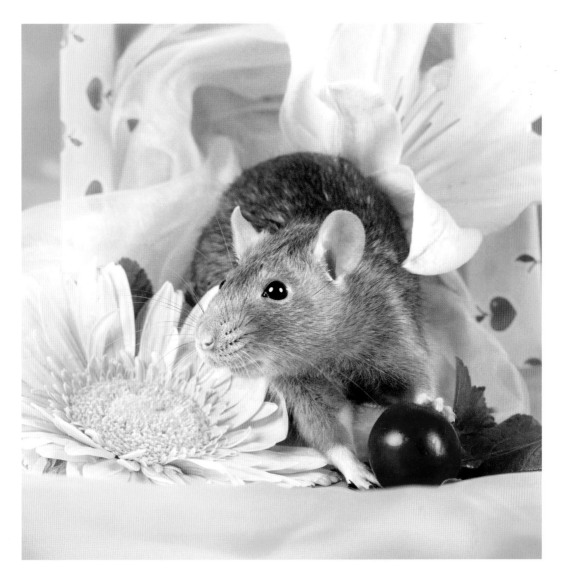

Cocaïne

This picture illustrated the month of April for the rat-themed calendar I mentioned earlier. Cocaïne was an adorable girl, though a bit hyperactive, and I had trouble getting nice shots of her. However, as soon as I added some fruit into the equation, she magically slowed down. I think that food might be the answer to every problem when it comes to photographing rats. Cocaïne reminded me a lot of my Fenrir, as she too had some clown-like behaviors.

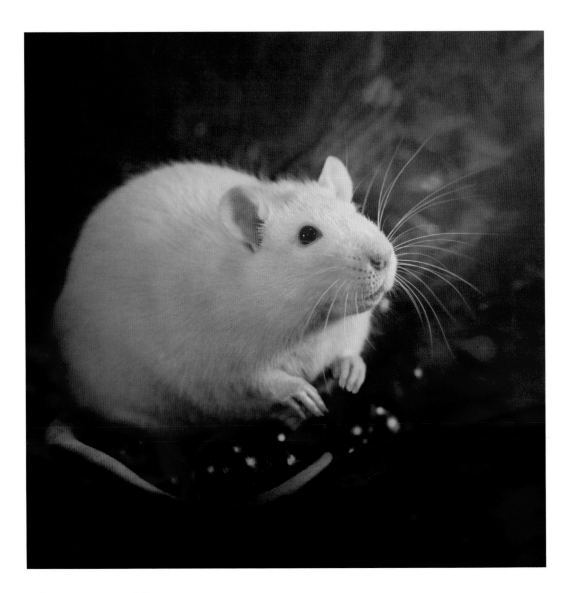

Pietro Pagello

Pietro Pagello was the brother of Feirefiz. He was adopted by my friend, Tiphaine, as they had grown very attached to each other while she was taking special care of him. He'd had a bad infection around his navel when he was a tiny baby, and his chances of living would have been quite reduced had Tiphaine not helped him to heal.

This adorable rat was very delicate and had a natural elegance that seemed evident in his every action. He was also very cuddly and would easily fall asleep to cheek scratches.

Adult male rescue rat. Fawn Roan, standard eared, standard coated.

Thjazi & Lothar

Adult male rats. Seal Point Siamese Hooded, standard eared, standard coated, and Black Mismarked Capped Headspotted, standard eared, velveteen coated.

How better to illustrate the importance of never letting rats live alone? These two adored each other and would spend a large part of their days napping together, comfortably installed in a small hammock or basket. Such social interactions are absolutely essential for rats' well-being. They can comfort each other, communicate through body language, perceive sounds humans cannot hear, groom each other, etc. Please, never force a rat to live alone!

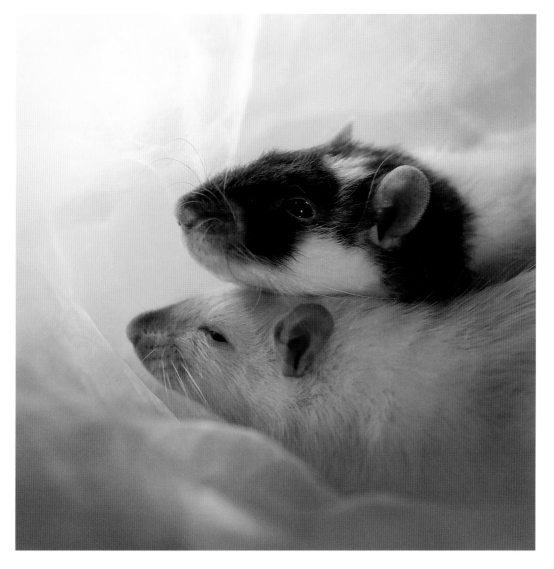

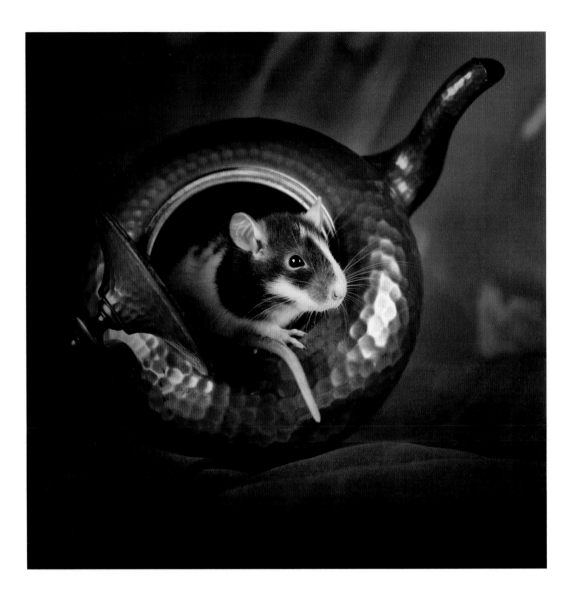

Never Say No to Panda

Never Say No to Panda was the brother of my sweet Gareth. He was with me for a few days before his owner could come to Paris to take him to his new home. He was a very gentle little boy, a bit shy at first, yet very playful once he got used to the noises and smells of my home. I had this old teapot, which really intrigued him; he tried to open it multiple times and failed, as he was too small. He seemed to be very happy to finally get a grasp of how it looked from the inside during this photo shoot.

Baby male rat.
Black Variegated
Blazed,
standard eared,
standard coated.

Dotty

Adult female rat.
Agouti Variberk
(Variegated Berkshire)
Headspotted,
standard eared,
standard coated.

I was a rat-sitter for Dotty, along with Dioné and Kihara. Dotty was extremely inquisitive and used to strike that typical "meerkat pose" to sniff around. I decided to try to capture it and, fortunately, succeeded. It is common for rats to stand on their hind legs when curious about something, as it helps them hear, see, and smell better. In this pose, they can grasp a larger amount of information about their surroundings.

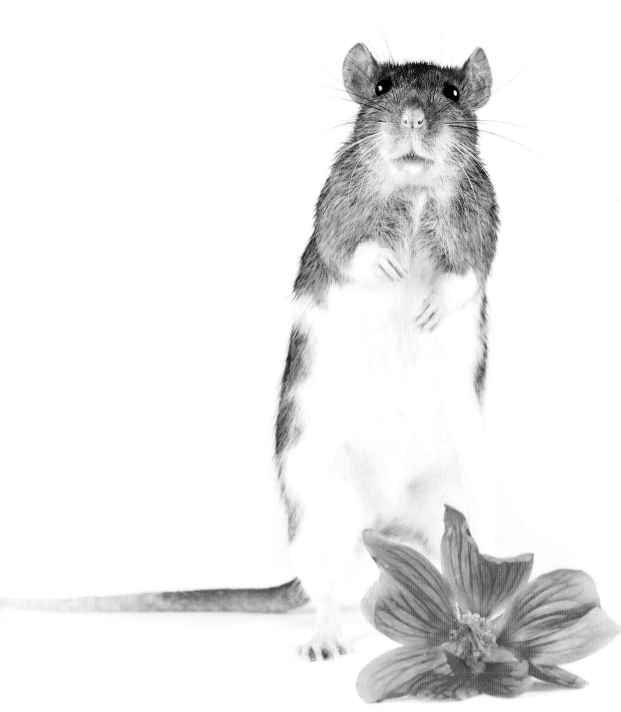

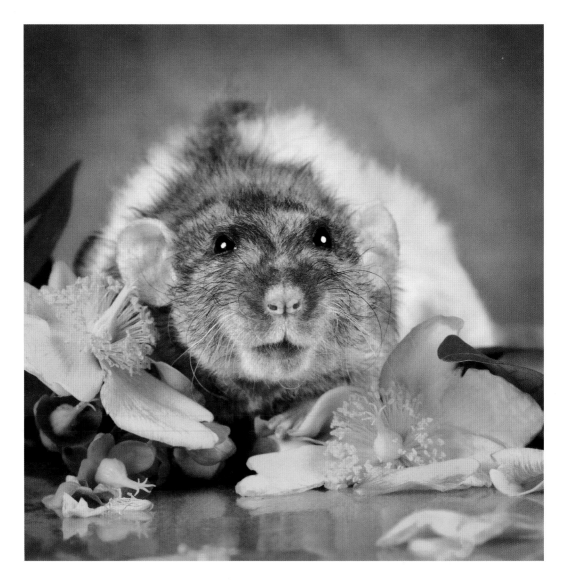

Kihara

Sweet Kihara seemed to smile, and I am glad I could capture her funny expression in this picture. This adorable and mellow-tempered rat was always willing to pose, as long as she could get some cuddles, or even better, cooked pasta, which is always a huge hit among rats. During this session, she was feeling so content that she could not stop boggling and bruxing (a sign of pure joy for rats), and most of the shots were very weird looking, as her eyes were bulging with happiness.

Senior female rat from an unplanned litter. Agouti Hooded, Dumbo eared, rex coated.

Heimdall

This was my first encounter with Heimdall, a gorgeous and very funny little rat born at La Tarte au Citron, a French rattery. He was a cousin of my adorable Feirefiz, and they both exhibited the same very clingy behavior, although Heimdall was a bit more playful than cuddly. Heimdall never grew really big compared to my other rats, but he was so energetic that he became the leader of the pack for some months, as the others grew tired of him jumping all around and immediately rolled onto their back when he approached.

Baby male rat.
Mink Varihooded
(Variegated Hooded)
Dumbo eared,
standard coated.

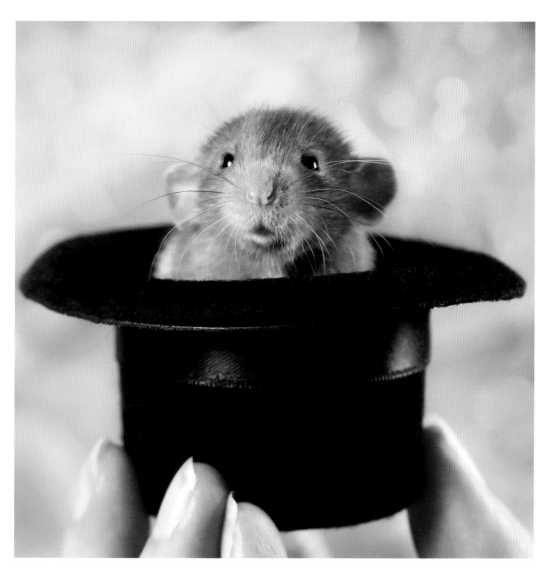

Stella & Feirefiz

Mother rats are usually very protective of their babies, and Stella was no exception. She originally belonged to a snake owner, "K," who bred rats to feed her reptiles, as she did not agree with the harsh condition pet shops' feeder rats endure. She, however, agreed to give Stella to my friend, Tiphaine, who raised Stella and her babies, as she wanted to avoid them being eaten. The gorgeous Stella had an amazing personality; she was quite protective toward other rats and the few people she loved, and was a very fast learner.

Adult female rat and baby male rat. Black Berkshire Head-spotted and Fawn Hooded, both standard eared and standard coated.

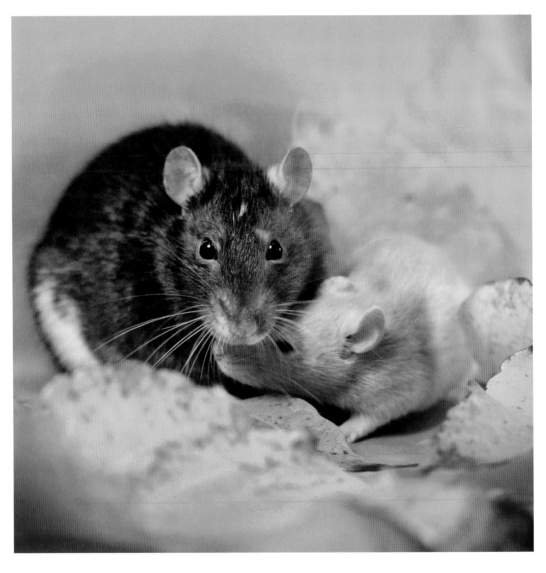

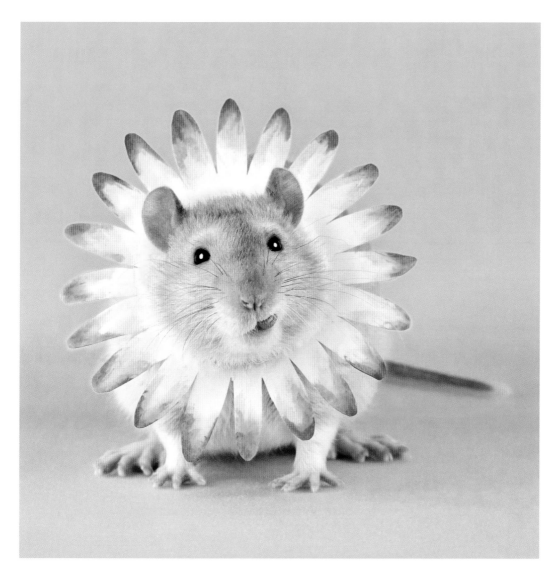

Tjall

*Young male rat.
Russian Blue Wheaten
Burmese Irish,
standard eared,
velveteen coated.*

Do not worry: no rat was harmed during the making of these photos, and Tjall did not even seem to notice he was wearing that huge flower collar (how is that even possible?). Though he could remove it by shaking his head a bit, he was way too interested in licking the remains of peach juice from his whiskers to bother doing so. I had to take that homemade collar off after some seconds because I felt quite guilty. This resulted in a good laugh, as Tjall stood looking at me, disgruntled that I had wiped off the peach juice in the process.

Photography Tips

Alpha

Adult female rat.
Black Hooded,
standard eared,
standard coated.

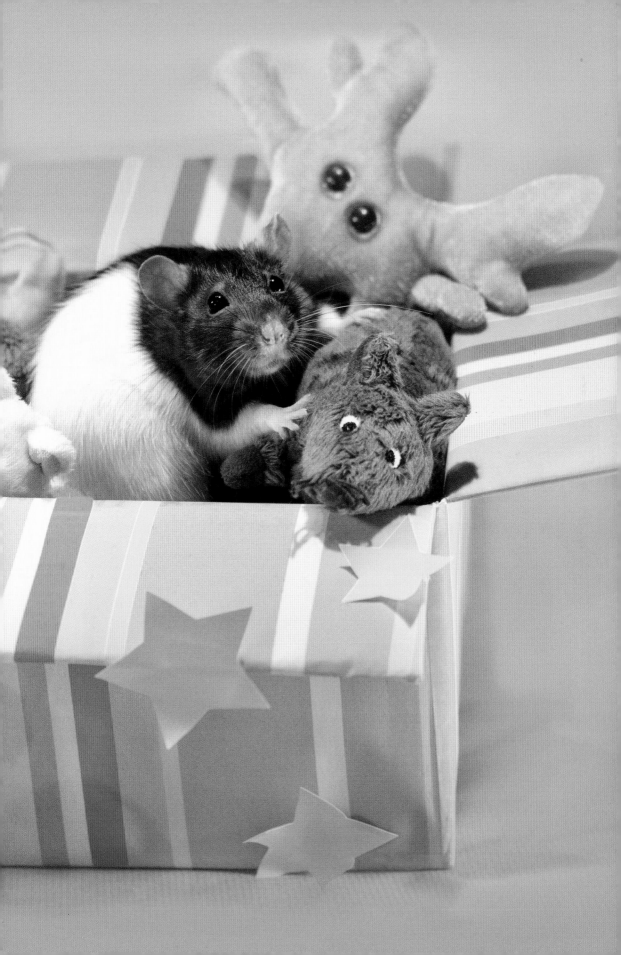

How to Prepare for a Shoot with Rats

First, you should know that it is very important not to force an animal into posing for a shoot if the animal looks stressed, tired, afraid, or simply does not want to cooperate. It is also important to make sure you are using safe props to decorate your scene. Avoid food and materials that are toxic to rats (as outlined in part 1) and any dangerous elements that cause choking or otherwise harm the subject.

Use a comfortable background such as soft fabric or paper. Cold and slippery surfaces are to be avoided, so the rats will be more likely to stay put in your mini photo studio and not try to run away.

I did not own professional gear when I started out. I used only desk lamps and natural light, plus some colored sheets of translucent plastic as filters. A simple chair or coffee table was enough to use as a support for my background elements, which I duct-taped to a wall or right to the back of the chair. I bought a cork board to pin elements onto later on. This proved quite useful. I have always used colored sheets of paper and cheap fabric for the backgrounds (mostly organza and polyester or cotton lining fabric), which I sometimes layered to produce a wide array of textures and visual effects. There is no need to invest in expensive materials: the only limit is your imagination. You can even use recycled bubble wrap, gift wrap, etc., as long as the material you choose is safe for the rats.

Make sure you have enough light to be able to set a high shutter speed (at least $^1/_{125}$ second), as rats are very active and will not stand still during the shoot.

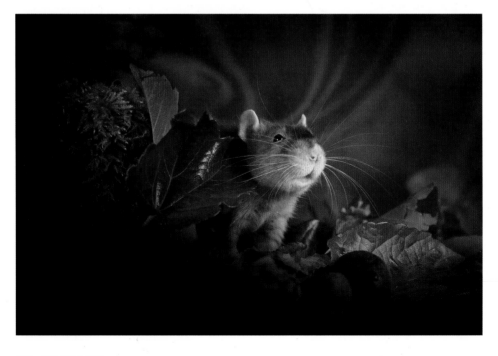

Camera & Lenses

A camera is just a tool. Do not feel limited if you do not own the latest pro DSLR. Focus on the lens instead. Choose one with a wide aperture to let in as much light as possible. Its focal length should allow you to get the whole scene in the frame while you hold your camera with one hand and pet or play with the rat with your other hand. Thus, telephoto or wide-angle lenses that crop the rat or make the background appear too large should be avoided.

I have always used a Canon 60mm f/2.8 macro lens (first mounted on a Canon EOS 350D, then on a 60D). I also tried a 50mm f/1.8 lens, which was surprisingly inexpensive but did a good job rendering fine details.

At Ease & "Posed"

Let us get straight to the point: rats will not actually pose. The photos in this book, except for the ones with sleeping rats, are action shots. Rats are curious, playful, smart, and like to explore new surroundings, so the mini photo studio instantly becomes a playground. Providing fruit, cooked pasta, or vegetables will encourage them to slow down so you can improve your odds of getting great pictures.

Always allow the rats to roam free in the mini studio for a while so they get used to their surroundings. Provide items that allow the shy rats to hide, especially if you are photographing traumatized rescue rats. Patience is key!

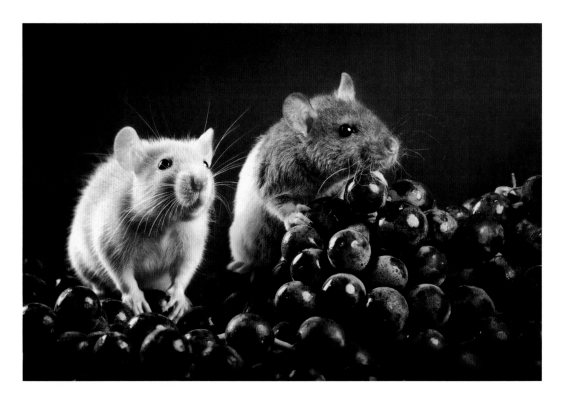

Lights & Camera Settings

I avoid shooting with flash, as rats have sensitive eyes. Instead, I use soft light sources—at least two—so the light is even enough to avoid major exposure issues. Placing the light sources on both sides of the scene usually works well (you can tell that this is what I did most of the time by looking at the catchlights in the rats' eyes), but I would advise you to get an additional light source or a reflector to ensure the darkest areas are properly exposed. Survival blankets, tinfoil, white glossy paper, and polystyrene foam sheets make nice reflectors.

Set the shutter speed no lower than $^1/_{125}$, though $^1/_{250}$ is better, as rats move very fast. The ideal aperture setting will depend upon the intensity of your light sources and your lens. Choosing too wide an aperture will not allow you to get the rat's whole head in focus, and setting it too narrow will produce underexposed images. (You can choose a higher ISO, but this will add some noise to the picture.) If you are not comfortable using your camera's settings, you can use a semi-automatic mode such as shutter speed priority and avoid ISOs above 1250.

The best way to get accurate color is to use your camera's custom white balance mode and a sheet of white paper, placed right where the rats will stand. Ensure the paper fills the frame, and take a properly exposed shot. This will serve to ensure good color for this setup.

Post-Processing

You will likely need to do some editing, even on the best pictures: removing a stain of fruit juice, softening a fabric fold, cloning a breadcrumb out, removing the excess noise in slightly underexposed pictures, etc. There is no shame in that: all the photos in this book have been slightly edited to get the best out of them while still remaining true to the original shot.

Shooting in RAW format allows for a much wider range of settings to be adjusted than does shooting in JPEG. You will not be able to get back some details on a slightly overexposed JPEG image, but you will be able to retrieve most of them in RAW.

As you cannot control where the rat will stand when the perfect "pose" happens, you will also often need to crop out the unnecessary parts of the background. You can use free softwares, such as Gimp, to do so. Once again, there is no need to go for the most expensive solutions.

I have been mostly using Adobe Camera Raw and Photoshop, which I learned by myself over the years. There are plenty of free tutorials available about lighting and color correction, and you may want to experiment with the various settings until you find the color style that suits you best. Just be sure to check out the final outcome on different screens if you are planning to print your pictures so you can spot color issues, which may not show on all devices.

Index